Mute Vol II #3 - Naked Cities – Struggle in the Global Slums

Published by Mute Publishing Ltd, 2006
No copyright Ⓝ unless otherwise stated

EDITOR
Josephine Berry Slater <josie@metamute.org>

DEPUTY EDITOR
Benedict Seymour <ben@metamute.org>

ASSISTANT EDITOR
Anthony Iles <anthony@metamute.org>

EDITORIAL BOARD
Josephine Berry Slater, Matthew Hyland
<matthewhyland@hotmail.com>, Anthony
Iles, JJ King <jamie@jamie.com>, Demetra
Kotouza <demetra@inventati.org>, Hari
Kunzru <hari@metamute.org>, Pauline van
Mourik Broekman, Benedict Seymour, Laura
Sullivan <alchemical44@yahoo.co.uk> and
Simon Worthington

PUBLISHERS
Pauline van Mourik Broekman
<pauline@metamute.org>
Simon Worthington
<simon@metamute.org>

DESIGN PRODUCTION
Laura Oldenbourg <laura@metamute.org>

GRAPHIC DESIGN
Damian Jaques <damian@aant.co.uk> of
AANTGraphicDesign, Simon Worthington and
Laura Oldenbourg

ADVERTISING
<advertising@metamute.org>

WEBSITE
www.metamute.org is powered by Drupal
and CiviCRM FLOSS Software, with additional
software services by our very own OpenMute
http://openmute.org

TECH SUPPORT
Mute office, FLOSS migration and support:
Antonio Pena <antoniostone@yahoo.es>
Web infrastructure: Darron Broad
<darron@kewl.org>

OPENMUTE
CTO: Darron Broad; technology design and
development: Simon Worthington and Laura
Oldenbourg; interactive and graphic design:
Raquel Perez de Eulate
<raquel@metamute.org>

INTERNS
Special thanks to:
Esiri Erheriene-Essi and Finn Smith

OFFICE
Mute, Unit 9, The Whitechapel Centre,
85 Myrdle Street,
London E1 1HQ, UK
T: +44 (0)20 7377 6949
F: +44 (0)20 7377 9520
e-mail: <mute@metamute.org>

SUBSCRIPTIONS
T: +44 (0)20 7377 6949
F: +44 (0)20 7377 9520
e-mail: <subs@metamute.org>
web: http://www.metamute.org/subs/

DISTRIBUTION UK
Central Books,
99 Wallis Road,
London, E4 5LN.
T: +44 (0)20 8986 4854
F: +44 (0)20 8533 5821

DISTRIBUTION US
Ubiquity Distributors,
607 Degraw Street
Brooklyn, NY 11217
T: +1 718 875 5491
F: +1 718 875 8047

CONTRIBUTING
Mute welcomes contributions of all kinds:
articles, visuals or collaborations. Please email
<mute@metamute.org> with your suggestions
or visit metamute.org where you can post
news, events and comments or contribute to
the Mute Public Library http://pl.metamute.org

The views expressed in Mute and Metamute
are not necessarily those of the publishers or
service providers

Mute is published in the UK by Mute
Publishing Ltd. and printed by OpenMute
http://openmute.org print on demand (POD)
book services in the USA and UK

COVER
The Mute team

ISSN 1356-7748
ISBN 0-9550664-3-3

Mute is supported by The
Arts Council of England

Table of Contents

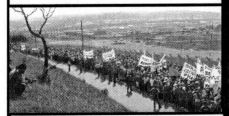

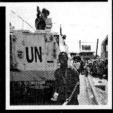

Thames Gateway Special

EDITORIAL
by Josephine
Berry Slater

As I write this I am sitting in my ex-local authority flat, looking out over the new vertical growth of London's pounding financial heart. My flat is in a highrise too, a block built in the late '60s at the peak of the social housing boom of the welfare state. No matter how its construction displaced and arguably helped destroy the community it apparently served, this style of development nonetheless aimed at providing London's working class with (relatively) spacious, light, central and well serviced homes. Now highrises are strictly for business – office blocks or yuppie apartments. I've watched several blowdowns in my neighbourhood in the past few years, as tower blocks take the blame for the 'dangerous' and 'alienated' existence of the urban poor. Meanwhile, out of my window, corporate highrises are slung up apace. Obviously there is nothing innately wrong with them – so long as they are pulsing with cash and city workers. Or, as in my case, sold off to private leaseholders.

The increasing gulf between these vertiginous bastions of capital and, when they are built at all, the low-rise dingy barracks of affordable housing, dramatises the general state of the world's divided cities. The poor, though required to build and service the swelling megalopolises, are apparently not welcome here. Mike Davis, whose book *Planet of Slums* has largely provoked this issue of *Mute*, cites figures which unquestionably prove the mass influx of humanity from the countryside into urban slums. However, these slums are themselves under threat. Largely the product of neoliberal economics – its sell-off of public assets, spiralling living

costs and structural adjustment programmes which render tradi-
tional modes of rural subsistence untenable, etc. – slums, as with
the UK's social housing under Thatcher, are now public enemy
number one. They often occupy centrally located zones which,
once considered unsavoury because too industrial, are now highly
desirable and hence valuable. While plans to build thousands of
new homes in the Thames Gateway may well end up creating a
sink of poor quality housing for London's low-paid service work-
ers, the centres of cities are becoming off limits to anyone but the
middle class and business.

This is nothing short of a new enclosure – real estate is bearing
the brunt of a general economic crisis in which credit fuelled con-
sumption masks an underlying lack of productivity and economic
expansion. Inflation and expropriation go hand in hand. Squatters
are thrown off the land without, in many cases, any viable rehousing
plans, just as the poor are shunted from welfare to workfare, without
any real prospect of employment. Another mode of expropriation is
also occurring at a cultural level – the spectre of what at *Mute* we've
been calling the 'shanty chic' aesthetic. As the bubble of convenience
culture and technologised hyper-mediation numbs the cultural
class, a vicarious worship of all things bricolaged, improvised and
threadbare – read pauperised – has taken hold. The acid bath of
poverty is the urbane consumer's psychic chemical peel of choice.
This admiration has strayed from the art world into the culture
industry in general – a new chain of restaurants in Paris and
London shamelessly, almost unconsciously, named Favela Chic now
serves up top-dollar cuisine at soup-kitchen style collective tables,
overlooked by an artlessly bricolaged DJ booth. Meanwhile the
spectacle of the South's slum dwellers is served up to the cinema
goers of the North, mixing equal measures of desperation and
glamorous dreams of life beyond the law.

In this issue we have tried to explore both the production and
abduction of a 'surplus humanity' adrift in the world's cities. While
cautious of the tendency to lapse into a Rem Koolhaas style cele-
bration of the improvisatory ingenuity of the precarious class, to
Learn from Lagos as it were, this issue nevertheless attempts to
reveal a 'politics of the poor', which meshes together dissent in the
slums of Port au Prince, Delhi, Durban and São Paulo with the pen
pricks of poets and the living words of dead rappers. ⌐ϟ

Wizards of OS 4

WOS e.V. In Cooperation with WG Computer Science & Society of Humboldt University Berlin, Tesla Berlin and c-base

International Conference
14 - 16 September 2006
Columbiahalle, Berlin

wizards-of-os.org

INFORMATION FREEDOM RULES!

Urban analyst Mike Davis' bleak prognosis for the future of the city in his article *Planet of the Slums* has catalysed much discussion and helped spark this issue of *Mute*. Here, Iain Boal reviews Davis' book-length study of the same name

21ST CENTURY NOIR
by Iain Boal

While crews were still excavating the remains of dead firefighters and stockbrokers from the crater that was once the World Trade Center, the Larsen B ice shelf in Antarctic suddenly collapsed. Sixty stories thick and covering more than 1300 square miles, the shelf had survived every warm pulse since the end of the Pleistocene. Yet in a mere few weeks, it pulverised – like a window hit by a cannonball – into thousands of iceberg shards…We don't need Derrida to know which way the wind blows or why the pack ice is disappearing.

– Mike Davis, postscript to 'Strange Times Begin' [1]

To anyone inside, and to many beyond, what passes for the radical academy, this is the unmistakable voice of Mike Davis, anatomist-in-chief of what Naomi Klein has dubbed 'disaster capitalism'.

His dispatch from post-Katrina New Orleans – a powerful blend of vivid *reportage* and trenchant analysis – was vintage Davis. It is hard to think of anyone else with his ability to jump scale so tellingly from the micro-topographies of class and race to the hydrometeorology of the Mexican Gulf. Davis' bulletins from the disaster zones of modernity are beacons in a dark time.

He announced his arrival as a writer with a remarkable three-part essay, composed in the mid-1980s, which appeared as the front half of his first book, *Prisoners of the American Dream*. The essay, 'Labour and American Politics' is still an essential synopsis for students of the history of the American working class. When, four years later, Davis published his noir history of Los Angeles, *City of Quartz* was immediately recognised as a modern classic in urban studies, even if LA boosters resented his muckraking and called him a pornographer of apocalypse. Davis made even his friends nervous when he quite seriously proposed, in *Ecology of Fear*, to 'let Malibu burn', on the grounds that it was a natural fire corridor that would inevitably burn anyway and that anything else amounted to a massive hidden subsidy to entertainment industry plutocrats. Kevin Starr, the dean of California historians, proclaimed that fifty years ago Davis would have made a good priest, but that 'If he doesn't watch it, he'll become a crank'. *The Monster at Our Door*, Davis's recent book on the likelihood of an avian flu pandemic under prevailing conditions of poultry capitalism in

Asia, probably confirmed Starr in his judgment. The cover art may have verged on parody, but the analysis inside is rooted in a materialist account of the factors now favoring the lethal evolution of the H5N1 virus.

It is now over a decade since Davis, in his contribution to an eco-socialist forum convened on the UC Santa Cruz campus

micro-credit and cooperative lending have become 'an urban cargo cult' among NGOs

by the economist James 'Crisis' O'Connor, turned his attention to the emerging mega-slums of the global south. He called them, 'sociologically, UFOs'. Davis was pushing into new territory for a Californian urbanist, far removed from the lilywhite utopianism of an Ernest Callenbach dreaming of a green Berkeley, with the ghettoes of Oakland and Richmond nowhere to be seen.

A significant pair of closely related words – derived from the Latin adjective *urbanus* – entered the English language simultaneously at the beginning of the 17th century. The historical identification of 'urban' with 'urbane' may not survive

contact with the developments portrayed in Davis' latest work. If urbanity seems outdated, even residual, it turns out that the career of 'urban' is only just beginning.

Planet of Slums is the opening salvo of a large project first announced in a manifesto with the same title published in *New Left Review* 26 in the spring of 2004. In that landmark essay Mike Davis laid out the rationale for an urbanism adequate to the 21st century. Davis opened with two striking observations – that worldwide, for the first time in human history, there are now more people living in cities than in the countryside; and secondly, because the global hinterland has reached its maximum population, all future growth in the number of humans will happen in cities.

What makes these milestones ominous as well as striking is a third observation – that '95 percent of this final buildout of humanity will occur in the urban areas of developing countries'. The context, in other words, is military neoliberalism and the policies ('There is No Alternative') pursued by the specialists in immiseration belonging to the IMF/World Bank/US Treasury nexus. The result is, and will be, 'gigantic concentrations of poverty'.

Davis acknowledges the work of Jan Breman (*The Labouring Poor in India*, Oxford, 2003) and Jeremy Seabrook (*In the Cities of the South*, Verso, 1996) as models of the new urbanism, and in the immediate background, both as stimulus and framework, UN-Habitat's report *The Challenge of the Slums: Global Report on Human Settlements 2003*. Davis uses these three texts as lodestars to navigate the virtually

uncharted world of the new mega-cities. He is a master of the astounding statistic: who would possibly have guessed that 85 percent of the urban residents of the developing world 'occupy property illegally'.

We have to wait, however, until the final chapter, 'A Surplus Humanity?', to find the conceptual centre of *Planet of Slums*. In what amounts to a research programme for critical urbanism in the 21st century, Davis frames it by drawing a theoretical connection to the 19th century city. He posits that the recent growth of a vast global informal proletariat living in the new slum-world is undergoing a process of 'urban involution'. This is by analogy with Clifford Geertz's notion of 'agricultural involution' describing the spiral of labour self-exploitation in the Indonesian countryside in the early 1960s. Davis suggests that the potential for urban involution existed among the displaced peasantries of the 19th century European industrial revolutions, but the rise of mega-Dublins was prevented by mass emigration to the settler societies of the western hemisphere and Siberia. Today, surplus labour faces hardened borders, making large-scale migrations impossible; slums become sinks of human labor and are the only 'solution' to the warehousing of the surplus humanity produced by the structural adjustment programs of the IMF. These settlements have, says Davis the ironist, 'a brilliant future', and will contain perhaps 20 billion people by the year 2030. Davis the Marxist ponders the historical fate of 'this fastest growing and most unprecedented social class on earth.' He muses: 'To what extent does an

informal proletariat possess that most potent of Marxist talismans: "historical agency"?...Or is some new, unexpected historical subject, á la Hardt and Negri, slouching toward the supercity?'

These questions drive to the heart of the Marxist imaginary and its view of human agency in contrast to the traditional anarchist faith in autonomy – the inertness of the masses versus the self-activity of the populus. Although he has previously called for a re-visiting of the anarchist urbanism of figures like Pietr Kropotkin and Patrick Geddes (given the mostly disastrous record of 20th century liberal-Keynesian and Stalinist city-planning), Davis the Ironic Marxist, in the chapter on 'Illusions of Self-Help', really puts the boot into John Turner, disciple of Geddes and erstwhile contributor to Freedom, the journal founded by Kropotkin. Turner, an arts-and-crafts-inspired architect (his grandfather had worked with William Morris, and May Morris was his mother's godparent), had an epiphany after the big Peruvian earthquake of 1958, when he saw the results of facilitating communal self-help in the barriadas of Arequipa. Later, in 1976, the year of the first UN-Habitat conference, Turner published the fruits of his long experience with poor city-dwellers in Housing by People: Towards Autonomy in Building Environments. Its message turned out to be congenial to the agenda of Robert McNamara at the World Bank, or as Davis puts it, Turner 'was mesmerised by the creative genius he discerned at work in squatter housing...[and his] core program of self-help, incremental construction, and

legalisation of spontaneous urbanisation was exactly the kind of pragmatic cost-effective approach to the urban crisis that McNamara favored.' (p.71-2) However naïve or complicit or undialectical Turner may have been – and Davis does not hesitate to call his case an 'intellectual marriage' between anarchism and neoliberalism – it was certainly not the first or last time that a radical programme has been suborned. ('Flexible hours' was once a demand of radical feminists; 'We'll give you flexi-time', said Business, 'all of it!' And Marxists, shall we say, hardly have an unblemished record in the matter of collaboration with ruling powers.) Still, the essential point is that opponents of capitalism's life-world – whether they fly a red or a black flag – face a truly serious task, to theorise afresh popular agency in conditions of late modernity, and to understand why we find ourselves, as Retort put it in *Afflicted Powers*, 'living in an age defined by a terrible atavism – a plunging backward into forms of ideological and geo-political struggle that call to mind now the Scramble for Africa, now the Wars of Religion.' (p.14)

Certainly Marx and Engels would have been surprised by the decline of secular radicalism. For the moment at least, notes Davis, Marx has yielded the historical stage to Mohammed and the Holy Ghost. The rise of militant Islam and Pentecostal Christianity is only one of many striking features of the social ecology of the slumworld. Davis systematically skewers the regnant myths about the world's informal working class; urban studies at this level is now, it seems, theoretically bankrupt. The De Soto vision of bootstrap capitalism, of the global informal sector as 'a frenzied beehive' of micro-entrepreneurs – a view which underpins the World Bank/IMF/NGO strategy of the transubstantiation of poverty into capital – is predicated on a raft of false premises. In reality: De Soto's heroic voluntary micro-entrepreneurs are mostly displaced public sector workers forced into sub-subsistence; most participants in the informal economy are not, as imagined, self-employed but work for someone else – via, for example, the consignment of goods or the rental of a pushcart or rickshaw; there is growing inequality *within* the informal sector as well as between it and the formal sector; informality ensures extreme abuse of women and children; the informal economy generates jobs by fragmenting existing work and thus subdividing incomes (the 'urban involution' phenomenon); slum-dwellers turn in vast numbers to quasi-magical wealth appropriation, such as lotteries, pyramid schemes and religious devotion; micro-credit and cooperative lending initiatives have become 'something of an urban cargo cult among well-meaning NGOs' but they have little macro impact on the reduction of poverty, even in Dhaka, home of the Grameen Bank;[2] increasing competition within the informal sector is dissolving self-help networks and social solidarities essential to the survival of the very poor; the rise of the informal sector goes hand-in-hand with the growth in ethno-religious or sectarian violence.

It is no surprise, as Davis notes, that this last development has drawn the attention of the Pentagon, whose neo-Orientalist consultants and wargamers are assuming that the slum outskirts of 'feral, failed cities' of the Third World will be 'the distinctive battlespace of the twenty-first century'.

As if suspicious of his own attraction to the overdrawn and the terminal, and in this indispensible book to what might be called 'demographic reductionism' – whereby myriads of flesh-and-blood humans become pulverised into the dramatic statistics of poverty and immiseration, 'an existential ground zero beyond which there are only death camps, famine, and Kurtzian horror' – Davis closes *Planet of Slums* on the promise of a companion volume (co-authored with Forrest Hylton) whose topic will be 'the history and future of slum-based resistance to global capitalism'. That book will no doubt contain tales of heroic improvisation against tremendous odds, and insist on the role of human agency. (There is after all plenty of material fast accruing at the sites of Forrest Hylton's courageous dispatches and field work – Bolivia and the Andean region.)

And yet the book that Davis is really preparing to write will demand that extraordinary jumping of scale in time and space that is the Davis hallmark, thinking the quotidian-human and the geological together. It will stretch even the Davisian canvas. What such a book will entail he actually tells us in his original NLR manifesto: it will mean exploring 'the ominous terrain of...interaction' between 'the dangers of global warming [and] the global catastrophe of urban poverty.'

If the conditions requiring such a report do come to pass (and who can say they won't?), Davis will not be able to write it from either of his two favorite cities, lying at sea level on the Pacific and Atlantic littorals – Los Angeles and Belfast. One minor consolation will be the inundation of the Santa Monica real estate brokers who tried to defame the author of *Ecology of Fear*, and now of *Planet of Slums*, naively believing that disasters, and rumors of disasters, were bad for business. ⟡

Mike Davis, *Planet of Slums*, Verso, 2006.
ISBN: 1844670228

Footnotes

1
Mike Davis 2002 postscript to 'Strange Times Begin' in *Dead Cities*, Verso, 2002 (p.414).

2
The Grameen Bank is a microfinance organisation started in Bangladesh that makes small loans (known as microcredit) to the impoverished without requiring collateral, http://en.wikipedia.org/wiki/Grameen_Bank

Iain Boal <retort@sonic.net> is a social historian of science and technics, associated with Retort. Their new broadside *All Quiet on the Eastern Front* [http://www.metamute.org/?q=en/node/8211] follows on *Afflicted Powers: Capital and Spectacle in a New Age of War* (Verso, 2006, 2nd edition)

Taking up the gauntlet of pessimism thrown down by Mike Davis' account of the global slum epidemic, Richard Pithouse draws on his involvement with the struggles of slum dwellers in Durban to offer an alternative and engaged perspective. Against *Planet of Slums'* homogenisation of slum life, misrepresentation of slum politics, and 'imperialist' methodology, he argues for an analysis grounded in specific settlements, histories, people and struggles – a 'politics of the poor'

THINKING RESISTANCE IN THE SHANTY TOWN by Richard Pithouse

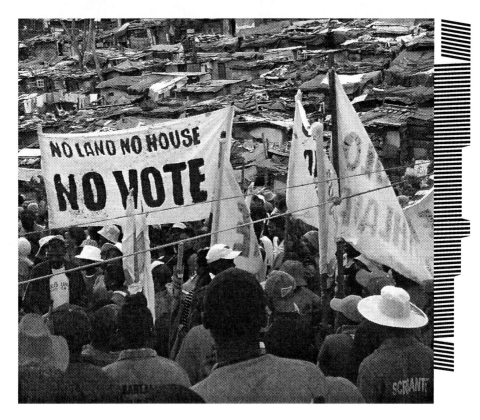

n 1961 Frantz Fanon, the great philosopher of African anti-colonialism, described the shack settlements that 'circle the towns tirelessly, hoping that one day or another they will be let in' as 'the gangrene eating into the heart of colonial domination'. He argued that 'this cohort of starving men, divorced from tribe and clan, constitutes one of the most spontaneously and radically revolutionary forces of a colonised people'. Colonial power tended to agree and often obliterated shanty towns, usually in the name of public health and safety, at times of heightened political tension.

But by the late 1980s the World Bank backed elite consensus was that shack settlements, now called 'informal settlements' rather than 'squatter camps', were opportunities for popular entrepreneurship rather than a threat to white settlers, state and capital. NGOs embedded in imperial power structures were deployed to teach the poor that they could only hope to help themselves via small businesses while the rich got on with big business. At the borders of the new gated themeparks where the rich now worked, shopped, studied and entertained themselves the armed enforcement of segregation, previously the work of the state, was carried out by private security.

Image: Foreman Road
Protest, 14 November
2005. Indymedia South
Africa

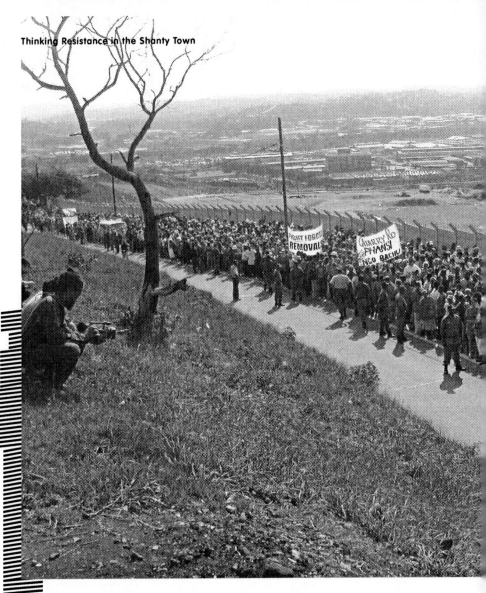

There are now a billion people in the squatter settlements in the cities of the South. Many states, NGOs and their academic consultants have returned to the language that presents slums as a dirty, diseased, criminal and depraved threat to society. The UN actively supports 'slum clearance' and in many countries shack settlements are again under ruthless assault from the state. Lagos, Harare and Bombay are the names of places where men with guns and bulldozers come to turn neighbourhoods into rubble. The US military is planning to fight its next wars in the 'feral failed cities' of the South with technology that can sense body heat behind walls. Once no one can be hidden soldiers can drive or fire through walls as if they weren't

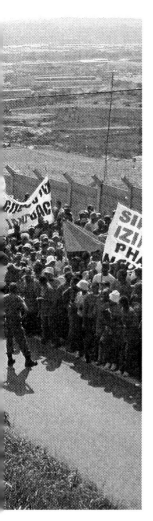

Image: March from the
Kennedy Road
Settlement, early 2005.
Indymedia South Africa

there. Agent Orange has been upgraded. Gillo Pontecorvo's great film *The Battle of Algiers* is used as a training tool at West Point. The lesson seems to be that that kind of battle, with its walls and alleys that block and bewilder outsiders and give refuge and opportunity to insiders, must be blown into history. The future should look more like Fallujah.

Leftist theories that seek one agent of global redemption are generally less interested in the shack settlement than the NGOs, UN or US military. Some Marxists continue to fetishise the political agency of the industrial working class and contemptuously dismiss shack dwellers as inevitably reactionary 'lumpens'. The form of very metropolitan leftism that heralds a coming global redemption by immaterial labourers is more patronising than contemptuous and concludes, in Michael Hardt and Antonio Negri's words, that: 'To the extent that the poor are included in the process of social production … they are potentially part of the multitude'. Computer programmers in Seattle are automatically part of the multitude but the global underclass can only gain this status to the extent that their 'biopolitical production' enters the lifeworld of those whose agency is taken for granted. The continuities with certain colonial modes of thought are clear.

But other metropolitan leftists are becoming more interested in the prospects for resistance in shanty towns. Mike Davis' first intervention, a 2004 *New Left Review* article, 'Planet of Slums', famously concluded that 'for the moment at least, Marx has yielded the historical stage to Mohammed and the Holy Ghost' and so 'the Left (is) still largely missing from the slum'. This was a little too glib. For a start the left is not reducible to the genius of one theorist working from one time and place. And as Davis wrote these words militant battles were being fought in and from shack settlements in cities like Johannesburg, Caracas, Bombay, Sao Paulo and Port-au-Prince. Moreover proposing a Manichean distinction between religion and political militancy is as ignorant as it is silly. Some of the partisans in these battles were religious. Others were not. In many instances these struggles where not in themselves religious but rooted their organising in social technologies developed in popular religious practices. Davis' pessimism derived, at least in part, from a fundamental methodological flaw. He failed to speak to the people waging these struggles, or even to read the

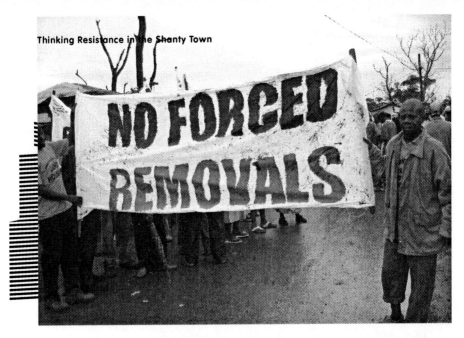

work produced from within these resistances and often read his imperial sources – the UN, World Bank, donor agencies, anthropologists etc. – as colleagues rather than enemies.

At around the same time as Davis wrote his *Slums* paper Slavoj Žižek, writing in the *London Review of Books*, argued that the explosive growth of the slum 'is perhaps the crucial geopolitical event of our times'. He concluded that we are confronted by:

> The rapid growth of a population outside the law, in terrible need of minimal forms of self organisation ... One should resist the easy temptation to elevate and idealise slum-dwellers into a new revolutionary class. It is nonetheless surprising how far they conform to the old Marxist definition of the proletarian revolutionary subject: they are 'free' in the double meaning of the word, even more than the classical proletariat ('free' from all substantial ties; dwelling in a free space, outside the regulation of the state); they are a large collective, forcibly thrown into a situation where they have to invent some mode of being-together, and simultaneously deprived of support for their traditional ways of life...The new forms of social awareness that emerge from slum collectives will be the germ of the future ...

Žižek, being Žižek, failed to ground his speculative (although tentative) optimism in any examination of the concrete. But it

Image: Foreman Road
protest, early 2006.
Indymedia South Africa

had the enormous merit of, at least in principle, taking thinking *in* the slum seriously.

As Alain Badiou explains, with typical precision, there can be no formula for mass militancy that holds across time and space:

> A political situation is always singular; it is never repeated. Therefore political writings – directives or commands – are justified inasmuch as they inscribe not a repetition but, on the contrary, the unrepeatable. When the content of a political statement is a repetition the statement is rhetorical and empty. It does not form part of thinking. On this basis one can distinguish between *true political activists* and *politicians* ... True political activists *think a singular situation*; politicians do not think.

The billion actual shack dwellers live in actual homes in communities in places with actual histories that collide with contemporary circumstances to produce actual presents. Many imperial technologies of domination do have a global range and do produce global consequences but there can be no global theory of how they are lived, avoided and resisted. Even within the same parts of the same cities the material and political realities in neighbouring shack settlements can be hugely different. This is certainly the case in Durban, the South African port city, from which this article is written. There are 800,000 shack dwellers in Durban but the settlements I know best are in a couple of square kilometres in valleys, on river banks and against the municipal dump in the suburb of Clare Estate. In this small area there are eight settlements with often strikingly different material conditions, modes of governance, relations to the party and state, histories of struggle, ethnic makeups, degrees of risk of forced removal and so on. In the Lacey Road settlement, ruled by an armed former ANC soldier last elected many years ago, organising openly will quickly result in credible death threats. In the Kennedy Road settlement there is a radically open and democratic political culture. Kennedy Road has a large vegetable garden, a hall and an office and some access to electricity. In the Foreman Road settlement the shacks are packed far too densely for there to be any space for a garden and there is no hall, office or meeting room and no access to electricity.

Although Davis notes the diversity within the shanty town in

the absence of the state and traditional authority can enable a rare degree of political and cultural autonomy

principle, in practice his global account of 'the slum' produces a strange homogenisation. This is premised on a casual steamrolling of difference that necessarily produces and is produced by basic empirical errors. For instance a passing comment on South Africa reveals that he does not understand the profound distinctions between housing in legal, state built and serviced townships and illegal, squatter built shacks in unserviced shack settlements. He casually asserts as some kind of rule that shack renters, not owners, will tend to be radical. No doubt this holds in some places but it's far from a universal law of some science of the slum. In fact most of the elected leadership in *Abahlali baseMjondolo* (the Durban shack dwellers' movement whose local militancy has, to paraphrase Fanon, made a decisive irruption into the national South African struggle) are owners, or the children or siblings of owners.

Robert Neuwirth's *Shadow Cities: A Billion Squatters, A New Urban World*, also published this year, is vastly more attentive to the actual circumstances and thinking of actual squatters. Neuwirth lacks Davis' gift for rhetorical flourish but his methodology is radically superior to Davis' often insufficiently critical reliance on imperial research. Neuwirth lived in squatter settlements in Bombay, Istanbul, Rio and Nairobi. Once there he took, as one simply has to when one is the ignorant outsider depending on others, the experience and intelligence of the people he met seriously. In Neuwirth's book imperial power has a global reach but there is no global slum. There are particular communities with particular histories and contemporary realities. The people that live in shanty towns emerge as people. Some are militants in the MST or the

PKK. Some just live for work or church or Saturday night at a club. In the Kiberia settlement in Nairobi he lived with squatters in mud shacks. In the Sultanbeyli settlement in Istanbul there is a 'seven-story squatter city hall, with an elevator and a fountain in the lobby'. Neuwirth also describes the very different policy and legal regimes against which squatters make their lives, the equally diverse modes of governance and organisation within squatter settlements and the varied forms and trajectories of a number of squatter movements.

Davis sees slums in explicitly Hobbesian terms. As he rushes to his apocalyptic conclusions he pulls down numbers and quotes from a dazzling range of literature and some of the research that he cites points to general tendencies that are often of urgent importance. Parts of his account of the material conditions in the global slum illuminate important facets of places like Kennedy Road, Jadhu Place and Foreman Road, which were the first strongholds of *Abahlali baseMjondolo*, as well as aspects of the broader situation people in these settlements confront. For example, Davis notes that major sports events often mean doom for squatters and here in Durban the city has promised to 'clear the slums', mostly via apartheid style forced removal to rural ghettos, before the 2010 football World Cup is held in South Africa. It is possible to list the ways in which Davis' account of the global slum usefully illuminate local conditions – postcolonial elites have aggressively adapted racial zoning to class and tend to withdraw to residential and commercial themeparks;

the lack of toilets is a key women's issue; NGOs generally act to demobilise resistance and many people do make their lives, sick and tired, on piles of shit, in endless queues for water, amidst the relentless struggle to wring a little money out of a hard corrupt world. The brown death, diarrhoea, constantly drains the life force away. And there is the sporadic but terrifyingly inevitable threat of the red death – the fires that roar and dance through the night.

But even when the material horror of settlements built and then rebuilt on shit after each fire has some general truth, it isn't all that is true. It is also the case that for many people these settlements provide a treasured node of access to the city with its prospects for work, education, cultural, religious and sporting possibilities; that they can be spaces for popular cosmopolitanism and cultural innovation and that everyday life is often characterised, more than anything else, by its ordinariness – people drinking tea, cooking supper, playing soccer, celebrating a child's birthday, doing school homework or at choir practice. It is this ordinariness, and in certain instances hopefulness, that so firmly divorces purely tragic or apocalyptic accounts of slum life from even quite brief encounters with the lived reality of the shack settlement. Furthermore, in so far as general comments about such diverse places are useful, an adequate theory of the squatter settlement needs to get to grips with the fundamental ambiguity that often characterises life in these places. On the one hand the absence of the state often means the material deprivation and suffer-

ing that comes from the absence of the basic state services (water, electricity, sanitation, refuse removal, etc.) required for a viable urban life. But the simultaneous absence of the state and traditional authority and proximity to the city can also enable a rare degree of political and cultural autonomy. This ambiguity is often a central feature of squatters' lives and struggles. A.W.C. Champion was the head of the famous African Industrial and Commercial Workers' Union (ICU) that helped to organise resistance against the atrocious material conditions in the huge *Umkumbane* settlement in Durban. Speaking in 1960, just after the state had destroyed the settlement and moved its residents to formal township houses outside of the city, he recalled *Umkumbane*, not only as a bad memory of shit and fire, but also as 'the place in Durban where families could breath the air of freedom'.

Neuwirth is able to capture this ambiguous aspect of shack life. He doesn't shy away from the horror of the conditions in some settlements. Indeed he begins with Tema, a resident of the Rocinha settlement in Rio, telling him that 'The Third World is a video game' and goes on to show why this statement matters. But because he has lived in the places that he describes and spoken to the people that he writes about he is able to capture the ordinariness of the ordinary life of people and communities and the fact that there are, at times, certain attractions to slum life. He quotes Armstrong O'Brian, a resident of the Southland settlement in Nairobi, who says, 'This place is very addictive. It's a simple life, but no one is restrict-

ing you. Nobody is controlling you. Once you have stayed here, you cannot go back.' Perhaps it is rumours of this air of freedom, this lack of control, that fill the sail on Žižek's radical hopes for the slum.

The question of the possibilities for shanty town radicalism should not, as Davis and Žižek assume, automatically be posed toward the future. Around the world there are long histories of shack dweller militancy. In Durban in June 1959 an organisation in the *Umkumbane* settlement called Women of Cato Manor led a militant charge against patriarchal relations within the settlement, against the moderate reformism of the elite nationalists in the ANC Women's League and against the apartheid state. This event still stands as a potent challenge to most contemporary feminisms. And progressive social innovation has not always taken the form of direct confrontation with the state. It is interesting, against the often highly racialised stereotypes of shack dwellers as naturally and inevitably deeply reactionary on questions of gender, to note that institutionalised homosexual marriage was in fact pioneered in South Africa in the *Umkumbane* settlement in the early 1950s. But the cultural innovation from shanty towns has not only been for the subaltern. It has often become part of suburban life. Bob Marley wouldn't have become Bob Marley without Trench Town and so much American music (Dylan, Springsteen etc) stems from a shack dweller – Woody Guthrie.

It also needs to be recognised that shanty towns are very often consequent to land invasions and that services, especially

water and electricity, are often illegally appropriated from the state. Fanon insisted that 'The shanty town is the consecration of the colonised's biological decision to invade the enemy citadel at all costs'. Most of the writing produced by contemporary imperialism tends to take a tragic and naturalising form and to present squatters as being passively washed into shack settlements by the tides of history. Unfortunately Davis gener-

squatters are 'not seizing an abstract right, they are taking an actual place'

ally fails to mark the insurgent militancy that is often behind the formation and ongoing survival of the shack settlement. So, for example, his naturalising description of Soweto as 'having grown from a suburb to a satellite city' leaves out the history of the shack dwellers' movement *Sofasonke* which, in 1944, led more than ten thousand people to occupy the land that would later become Soweto. However, Neuwirth's book is very good at showing that the shanty town often has its origins in popular reappropriation of land and often survives by battles to defend and extend those gains and to appropriate state services.

No doubt Human Rights discourse

takes on a concrete reality when one is being bombed in its name. But when grasped as a tool by the militant poor it invariably turns out to contain a strange emptiness. Hence the importance of Neuwirth's assertion of the value of the fact that squatters are 'not seizing an abstract right, they are taking an actual place'. But he sensibly avoids the mistake of assuming that popular reappropriation is automatically about creating a democratic commons. If the necessity or choice of a move to the city renders rural life impossible or undesireable, and if the cosmopolitanism of so many shanty towns puts them at an unbridgeable remove from traditional modes of governance, there is no guarantee that the need to invent new social forms will result in progressive outcomes. *Shiv Senna*, the Hindu fascist movement that built its first base in the shanty towns of Bombay, is one of many instances of deeply reactionary responses to the need for social innovation. At a micro-local level the authoritarianism and misogyny that characterises the governance of the Overcome Heights settlement, founded after a successful land invasion in Cape Town earlier this year, is another. As Neuwirth shows, choices are made, struggles are fought and outcomes vary. Many settlements are dominated by slum lords of various types. But this is not inevitable and does not justify Davis' Hobbesian pessimism about life in shack settlements. Communal ownership and democracy are also possible and there are numerous concrete instances in which they occur.

Neuwirth wisely resists the temptation

the everyday life of slum dwellers is characterised, above all, by its ordinariness

to produce a policy model for making things better and insists that 'The legal instrument is not important. The political instrument is' and that 'Actual control, not legal control is key.' His solution is old-fashioned people power – the 'messy, time consuming' praxis of organising. It is not a solution that sees squatters as a new proletariat, a messiah to redeem the whole world. It is a solution that sees squatters struggling to make their lives better. The point is not that the squatters must subordinate themselves to some external authority or provide the 'base' for some apparently grander national or global struggle. Squatters should be asking the questions that matter to them and waging their fights on their terms.

That is as far as the popular literature takes us. But the experience and thinking of shack dwellers' movements, some of which will travel well and some of which will not, can take us further. In Durban the experience of *Abahlali baseMjondolo* has shown that the will to fight has no necessary connection to the degree of material depriva-

tion or material threat from state power. It is always a cultural and intellectual rather than a biological phenomenon. It therefore requires cultural and intellectual work to be produced and sustained. Spaces and practices in which the courage and resilience to stay committed to this work can be nurtured are essential. Drawing from the diverse lifeworlds that come together to make the settlements and the movement requires a hybrid new to be woven from the strands of the old. Formal meetings are necessary to enable the careful collective reflection on experience that produces and develops the movement's ideas and principles. The music and meals and games and prayers and stories and funerals that weave togetherness are essential to sustain both a collective commitment to the movement's principles and a will to fight.

The *Abahlali* have also found that even if there is a growing will to fight no collective militancy is possible when settlements are not run democratically and autonomously. If they are dominated by party loyalists, the ragged remnants of a defeated aristocracy, slum lords or some combination thereof this will have to be challenged. Often lives will be at risk during the early moments of this challenge but the power of local tyrants simply has to be broken. The best tactic is to use the strength of nearby democratic settlements to ensure protection for the few courageous people who take the initiative to organise some sort of open display of a mass demand for democratisation. If a clear majority of people in a settlement come out to a meeting against the slum lords, and if the people

who break the power of the local tyrants immediately act to make open and democratic meetings the real (rather than performed) space of politics, then a radical politics becomes possible. Part of making a meeting democratic is declaring its resolute autonomy from state, party and civil society. Then and only then is it fully accountable to the people in whose name it is constituted. A movement must be ruthlessly principled about not working with settlements that are not democratic.

People fight constituted power to gain their share and to constitute counter power. Choices have to be made and adhered to. Any conception of shanty town politics that sees the mere fact of insurgency into bourgeois space as necessarily progressive in and by itself risks complicity with micro-local relations of domination and, because local despotisms so often become aligned to larger forces of domination, complicities with larger relations of domination. Despite the speculative optimism of certain Negrians, the fact of mere movement driven by mere desire for more life is not sufficient for a radical politics. A genuinely radical politics can only be built around an explicit thought out commitment to community constructed around a political and material commons. The fundamental political principle must be that everybody matters. In each settlement each person counts for one and in a broader movement the people in each settlement count equally.

After a movement has become able to put tens of thousands on the streets, brought the state to heel and made it into the *New York Times*, swarms of middle class

'activists' will descend in the name of left solidarity. Some will be sincere and alliances across class will be important for enabling access to certain kinds of resources, skills and networks. Sincere middle class solidarity will scrupulously subordinate itself to democratic processes and always work to put the benefits of its privilege in common. But, as Fanon warned, most of these 'activists' will 'try to regiment the masses according to a predetermined schema'. Usually they will try to deliver the movement's mass to some other political project in which their careers or identities have an investment. This can be at the level of theory in which case lies will be told in order that the movement can be claimed to confirm some theory with currency in the metropole. It can also be at the level of more material representation in which case the movement's numbers will be claimed for some political project that has no mass support but does have donor funding, or the approval of the metropolitian left so attractive to local and visiting elites. Tellingly these kinds of machinations tend to remain entirely uninterested in what ordinary people in the movement actually think, attempting instead to separate off and co-opt a couple of leaders to create an illusion of mass support – to turn genuine mass democratic movements into more easily malleable simulations of their formerly autonomous and insubordinate selves. Often struggle tourists will get grants to leave the alternative youth cultures of the metropole for a few weeks to come and assert their personal revolutionary superiority over the poor by writing articles ridden

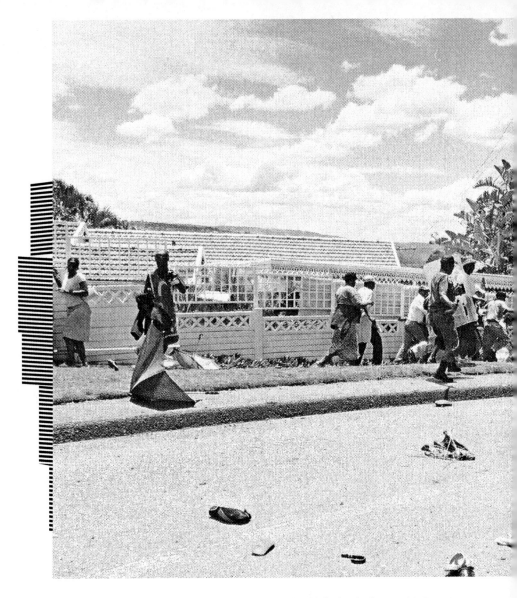

with basic factual inaccuracies that condemn the movement as insufficiently revolutionary. Invariably it will not occur to these people that it may be a good idea to ask the people in the movement who are missing work, getting beaten, threatened with murder, shot at and arrested in the course of their struggle what they think about their political choices. Old assumptions about

who should do the thinking and judging in this world show no signs of withering away. Indeed, on the safety of the elite terrain the middle class left will often openly express contempt for the people that they want to regiment. At times this is highly racialised. This is no local perversion. In Davis' book slums, and the people that make their lives in them, often appear as demonic.

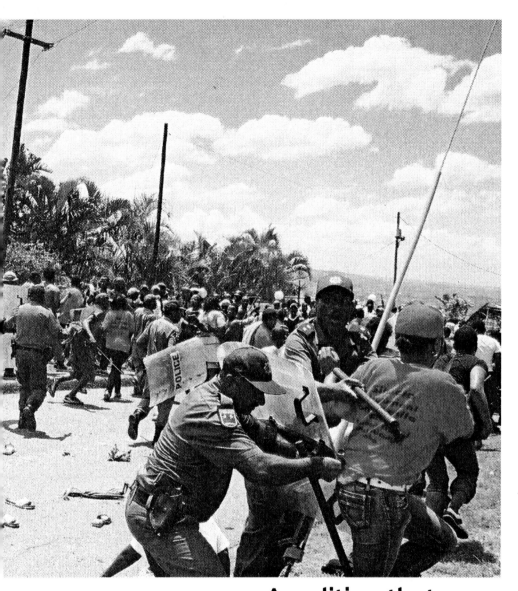

People who share some of the terrain of the middle class left (access to email, positions in universities or NGOs etc) and who do not find casual contempt for the underclass to be problematic, or who refuse to allow themselves to be used as bridges for attempts at co-option, will be excoriated on that terrain as divisive trouble makers. However they will, as Fanon wrote, find 'a

A politics that cannot be understood and owned by everyone is poison

Image: Foreman Road
Protest, 14 November
2005. Indymedia South
Africa

mantle of unimagined tenderness and vitality' in the settlements where politics is a serious project – where, in Alain Badiou's words, 'meetings, or proceedings, have as their natural content protocols of delegation and inquest whose discussion is no more convivial or superegotistical than that of two scientists involved in debating a very complex question'.

The middle class tendency to assume a right to lead usually expresses itself in overt and covert attempts to shift power away from the spaces in which the poor are strong. However the people that constitute the movement will in fact know what the most pressing issues are, where resistance can press most effectively and how best to mobilise. A politics that cannot be understood and owned by everyone is poison – it will always demobilise and disempower even if it knows more about the World Bank, the World Social Forum, Empire, Trotsky or some fashionable theory than the people who know about life and struggle in the settlements. The modes, language, jargon, concerns, times and places of a genuinely radical politics must be those in which the poor are powerful and not those in which they are silenced as they are named, directed and judged from without. Anyone wanting to offer solidarity must come to the places where the poor are powerful and work in the social modes within which the poor are powerful. Respect on this terrain must be earned via sustained commitment and not bought. All resources and networks and skills brought here must be placed in common. There must be no personalised branding or appropriation of work done. The

Post-Seattle struggle tourists must be dealt with firmly when they call the inevitable disinterest in their assumed right to lead 'silencing' and try to present that as an important issue. Local donor funded socialists must be dealt with equally firmly when they call people 'ignorant' for wanting to focus their struggle on the relations of domination that most immediately restrict their aspirations and which are within reach of their ability to organise a collective and effective fight back. Democratic popular struggle is a school and will develop its range and reach as it progresses. But a permanently ongoing collective reflection on the lived experience of struggle is necessary for resistances to be able to be able to sustain their mass character as they grow and to develop. It is necessary to create opportunities for as many people as possible to keep talking and thinking in a set of linked intellectual spaces within the settlements. Progress comes from the quality of the work done in these spaces – not from a few people learning the jargon of the middle class left via NGO workshops held on the other side of the razor wire. This jargon will tend to be fundamentally disempowering because of its general indifference to the local relations of domination that usually present a movement with both its most immediate threats and opportunities for an effective fight back. Moreover the accuracy and usefulness of its analysis will often be seriously compromised by its blindness to local relations of domination and how these connect to broader forces. People who represent the movement to the media, in negotiations and various forums, must be elected, mandated, accountable and

rotated. There must be no professionalisation of the struggle as this produces a vulnerability to co-option from above. The state, parties, NGOs and the middle class left must be confronted with a hydra not a head. There needs to be a self conscious development of what S'bu Zikode, chair of *Abahlali baseMjondolo*, calls 'a politics of the poor – a homemade politics that everyone can understand and find a home in'.

Some will say that none of this means that global capital is at risk. This is not entirely true – stronger squatters inevitably mean weaker relations of local and global domination. Given that states are subordinate to imperialism and local elites, confrontation with the state is inevitable and necessary. Because some of the things that squatters need can only be provided by the state the struggle can not just be to drive the coercive aspects of the state away. There also has to be a fight to subordinate the social aspects of state to society beginning with its most local manifestations and moving on from there. But in so far as it is true that squatter struggles are unlikely to immediately, as Davis will have it, produce 'resistance to global capitalism' what right has someone like Davis to demand that the global underclass fight global capital when he himself does not have the courage to take its representatives on his terrain as enemies? He concludes his book with the image of squatters fighting the US military with car bombs while he, as his book keeps making clear, has cordial and collegial relations with academic consultants for imperialism. This is not untypical. How many left intellectuals will really fight on their own terrain? We must

all, surely, assume the responsibility to make our stand where we are rather than projecting that responsibility on to others. And if we are going to enquire into the capacity of the global underclass to resist we should, at the very least, do this via discussion with people in the movements of the poor rather than via entirely speculative and profoundly objectifying social science. This is a route to a left version of the World Bank's mass production of social science that blames the poor for being poor by rendering poverty an ontological rather than historical condition.

The experience of *Abahlali* is that for most squatters the fight begins with these toilets, this land, this eviction, this fire, these taps, this slum lord, this politician, this broken promise, this developer, this school, this crèche, these police officers, this murder. Because the fight begins from a militant engagement with the local its thinking immediately pits material force against material force - bodies and songs and stones against circling helicopters, tear gas and bullets. It is real from the beginning. And if it remains a mass democratic project, permanently open to innovation from below as it develops, it will stay real. This is what the *Abahlali* call 'the politics of the strong poor'. This is why the *Abahlali* have marched under banners that declare them to be part of the 'University of *Abahlali baseMjondolo*'.

Richard Pithouse <Pithouser@ukzn.ac.za> lives in Durban where he has studied and taught philosophy. He has been part of *Abahlali baseMjondolo* since the movement's inception. For additional material and background on *Abahlali baseMjondolo* see http://www.metamute.org/taxonomy/term/181

'WE ARE UGLY, BUT WE ARE HERE'*:

HAITI SPECIAL

* Title of an essay by Edwidge Danticat, *The Caribbean Writer*, Volume 10, 1996
http://www.webster.edu/~corbetre/haiti/literature/danticat-ugly.htm

INTRODUCTION by Anthony Iles

Two years after the bicentenary of its independence, Haiti is paradigmatic of the dramatic new phase of capital accumulation occurring globally. Haiti, the first slave republic and inspiration to the liberation movements of Africa and the Caribbean, is more than just the poorest country in the Western Hemisphere. Having been exposed to 20 years of neoliberalisation and nearly 500 years of imperialism, Haiti presents both a concentrated vision of the ravages of capitalism upon a population and provides a study of the desperate means available to those who would oppose it.

Haiti is still in transition from the 'neo-colonial protectorate' (administered by the UN mission led by Brazilian, Canadian, French and Libyan forces under the moniker MINUSTAH) to a democratically elected government led by the coalition, *Fwon Lespwa* (Front of Hope), headed by René Préval, elected president on February 7, 2006. Préval is seen by many as the place holder for Jean-Bertrand Aristide, the popular politician-priest who rose to power at the head of the coalition of civil society organisations known as *Lavalas* (The Flood), and who was involuntarily exiled under the 'diplomatic protection' of US Marines in 2004.

The story of how Haiti's exceptional status as the experimental ground for plumbing new depths of poverty and violence arose is a long one, directly related to its pariah status as the first slave republic. In 1825, following Dessalines' establishment of the republic of Haiti, under the threat of economic isolation (and French gunboats) the Haitian government agreed to pay its former colonial master, France, 150 million francs as compensation for the loss of its slaves and plantations. As Peter Hallward points out, this imperial tribute to its former oppressor was paid by Haitians three time over 'through the slaves' initial labour, through compensation for the French loss of this labour, and then in interest (paid to French banks) on the payment of this compensation.'[1] France received the final instalment in 1947. Haiti has remained 'a systematically indebted country' ever since, in fact, from the perspective of international capital, it has remained in chronic debt ever since the originary moment of its hard won freedom.

In 1915 the US invaded and proceeded to occupy Haiti for over 19 years. The US imposed what Hallward calls an 'early form of structural adjustment', reinstating

the archaic system of corvée labour, expropriating peasants' land used to form new larger plantations and permitting foreign ownership of property.[2] The experience of the occupation also gave birth to a newly alert and politicised class in Haiti opposed to foreign interference, racial hierarchy and the imposition of wage labour. Haitians have also remained obstinate about land, 93 percent retaining access to their own property into the 1990s.[3]

The US has been Haiti's largest donor since 1973. Between 1995 and 1999, the US contributed roughly $884 million in assistance to Haiti. Haiti's dependence upon foreign aid has been the key to directing and sabotaging the extent of its political progress at home. The US' policy, directed through its loans, the multitude of NGOs it funds and its influence over the IMF and World Bank, has been to preserve what it sees as Haiti's key asset, identified in a USAID report as its 'highly productive, low-cost labor force'. This has entailed maintaining a minimum wage established during the Duvalier era of under $1 a day for as long as possible. Against disapproval from USAID and active resistance by sweatshop owners such as Andy Apaid, Aristide raised this to the still pitiful 36 gourdes (US $2.40) per day in 1995, though this applies to few Haitians. 70 percent of the population are 'unemployed' and 85 percent of those 'employed' work in the informal sector.[4] So, Aristide's populist pursuit of an apparently slightly less hyper-exploitative minimum wage is singularly irrelevant to most of the Haitian proletariat. In fact the wage is tied to piece work quotas

effectively enabling capital to intensify the pace of labour for its hopeful recipients.

> Because of rising consumer prices ... even after the recent increase, minimum wage workers in Haiti have less buying power now than they did in 1990, before President Aristide's election. And since Oct. 1, 1980, when dictator Jean-Claude ('Baby Doc') Duvalier first set the minimum wage at 13.20 gourdes, the real value of the minimum wage has declined by almost 50%.[5]

The Haitian wage is useful to US capitalists for two reasons, not only does it maintain a pool of cheap, easily available labour close to home, it sets the bar under which other labour markets in the region must limbo if they wish to compete.

> Wages in Haiti are lower than in the Dominican Republic, Jamaica, Honduras, El Salvador, Guatemala and Nicaragua. In other words, Haiti defines the wage floor for the entire Western Hemisphere.[6]

The devaluation of the wage, arbitrary violence, and the instability that has accompanied coup attempts and continues under the UN's 'protection', have driven innumerable Haitians to attempt the difficult passage across to the US mainland, or to seek work in the factories and sweatshops of the Dominican Republic.

The crippling economic hardship faced by Haitian governments has readily

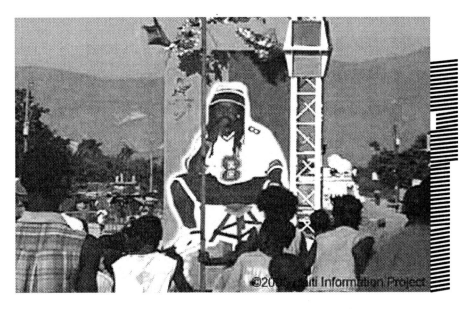

Image: Boulevard 'Dread' Wilmer named in honour of the murdered rapper and community activist

been passed on to its people. Under the regime of economic neoliberalisation Haitian and foreign businessmen set up sweat-shops taking advantage of sub-contracts from Walt Disney Corporation, Sears, Kmart, Sara Lee Corp., H.H. Cutler Co. for the production of goods to be sold at stores such as Wal-Mart, Kmart, J.C. Penney, and Kids R Us. 'Export zones' in the country-side, particularly along the border of the Dominican Republic, wel-comed capital to tax free heaven, whilst peasants unable to realise a price for their produce, left the land.

The profitability of these new enterprises was predicated on docile and compliant workers:

> In April, 1995, a worker who refused to work on Sunday so that he could go to church was fired. When he returned to pick up his severance pay, the manager called the UN police and reported a burglar on the premises. The UN police arrived and promptly handcuffed the worker. After protests from the other employees, the UN police finally let the worker go. The next day, management began firing, three at a time, four at a time, all those workers who had protested the arrest.[7]

In these zones capital, not labour, has rights. Workers are prohibited to strike, unionise or otherwise contest their lot. Polite refusal is often their only option:

> ...some workers unable to find time to rest either at work or at home resorted to cunning, for example feigning sickness in order to gain 2 or 3 days of paid leave. Here as well, a self-perpetuating conflict develops as some bosses become aware of these practices and refuse to believe any worker who claims to be sick.[8]

During the 1980s and 1990s Haiti's nationalised factories and resources were sold, often to foreign investors and for less than their real value. The new owners shut down production of sugar and flour. Once the world's largest producer of refined sugar, the country became an importer. On top of this, Haiti, like many Third World countries, has been flooded with cheap (subsidised) rice produced in the US.[9] The increased cost of living combined with the lowest wage in the region reduced the average standard of living, except for a rich elite, generally to starvation levels. Between 1978 and 1982 biological warfare arrived in Haiti in the form of swine fever. An outbreak in the US put pressure on the Government of Haiti to exterminate the native creyol pig population and, under a USAID program costing $30 million, replaced it with animals imported from the US. Requiring superior living conditions and more feed, the Haitian peasants quickly nicknamed the new breed 'prince à quatre pieds,' (four-footed princes) - luxuries

way beyond the means of most ordinary Haitians.[10] The successive attacks on Haitians' ability to subsist coupled with the introduction of 'export zones' in the countryside drove peasants from the land to the expanding slums of Port-au-Prince such as Cité Soleil, La Saline and Bel Air. Cité Soleil, the largest and the poorest, has approximately 300,000 inhabitants.

It is impossible, writing from London, to present an adequate picture of life on a dollar a day in Cité Soleil. Nonetheless, reading between the lines of reports and NGO 'visions' we can approximate a picture of how the residents of Haiti's slums have responded to the occupying forces of MINUSTAH and the interests of local and foreign capital they protect.

In January during the lead up to the 2006 presidential elections for Haiti, sweatshop magnate Andy Apaid and Raymond Boulos, president of the Haitian Chamber of Commerce and Industry, (alleged to have made his fortune selling the cadavers and blood plasma of dead Haitians to the US medical industry), called a general strike in the name of the Group 184, a self-styled cartel of NGOs acting in Haiti's interests.

> Driving through Port-au-Prince, we observed that the doors of major businesses such as Texaco, Shell, Scotia Bank, and upscale grocery stores remained shut. However, for the majority of Haiti's population who slave away to bring home a per-capita income of $200 per year, the day continued as if normal. Workers who toil in the informal

economy – street vendors, runners, tap-tap (taxi) operators – lined the streets, unable to skip a day's work just because the island's wealthiest said so.[11]

The strike was called to put pressure on MINUSTAH forces to 'clamp down harder on crime and kidnappings', but in effect only further polarised the two planets: one inhabited by the poor and the other, high up on the hills of Port-au-Prince, occupied by the elite.

Early in the morning of 6 July, more than 350 UN troops stormed Cité Soleil in a military operation. Its target was rapper and community activist Emmanuel 'Dread' Wilmer who was killed along with four of his entourage and 12 unarmed civilians.[12] His supporters say Wilmer had educated and organised the community in order to defend themselves from right-wing guerilla attacks on residents of Cité Soleil. A similar process was going on in another of Port-au-Prince's slums in 2005:

> We, the residents of Bel Air, took over our neighbourhood. We erected barriers at the crossroads to prevent the police and the white military from entering our area. We also set up a special watch to warn the residents of attack from both the official forces and from the paramilitary groups, the reconstituted death squads. This rebellion in Bel Air continued for several months before it was quashed by the United Nations soldiers last December.[13]

These self-organised approaches are in stark contrast to those initiated by Wyclef Jean of hip hop band The Fugees. His USAID supported charity 'Yele Haiti' celebrated its one year anniversary recently, bringing Angelina Jolie and Brad Pitt to pose in front of children's prisons and other sites of interest in Port-au-Prince. Wyclef encourages Haiti's poor to accept the conditions violently imposed by UN soldiers including an unelected provisional government and the minimum wage of $2 a day.

> Jean has so much street cred that he has convinced aspiring young slum rappers to compete for the best jingle about such socially conscious topics as cleaning streets or protecting the environment.[14]

While Wyclef, exemplary poor-kid-made-good through the music industry, tries to instill liberal values in the downtrodden and absolutely exposed, the Haitian proletariat are busy with the 'anti-social' practice of feeding, housing and defending themselves in the adverse conditions imposed by Wyclef's sponsors, the US state department, MINUSTAH and, indirectly, The World Bank and the IMF. The pragmatism of Haitians in the face of this obscene military-industrial-entertainment complex is attested to by the apt conclusion of Wyclef's vainglorious triumphal march through Port-au-Prince:

> Decked out as Haiti's revolutionary hero Jean-Jacques Dessalines, complete with a tri-cornered hat, swashbuckler's boots, glittering sword and ruffled shirt, the former Fugees front man would ride a float in Haiti's biggest festival, a real lion at his side ... And when Jean left his float at the end of Carnival, hordes of people stormed it, carting off instruments and a laptop. The crowds also tried to let the lion loose.[15] ⌇

Image: Angelina Jolie, Brad Pitt and Wyclef Jean in Haiti, January 13, 2006, making the Ye'le hand sign that symbolises 'stop the violence' with one hand and 'love & peace' with the other

Footnotes

1

Peter Hallward, 'Option Zero in Haiti',
http://www.newleftreview.net/NLR26102.shtml

2

Corvée labour '... a type of annual tax that is payable as labour by the serf or villein for the monarch, vassal, overlord or lord of the manor... The corvée was abolished in France on August 4, 1789. It had been a hated feature of the ancien régime. Today the term is also used for other forms of unpaid mandatory labour.'
http://en.wikipedia.org/wiki/Corv%C3%A9e

3

'Since 1793 the abolition of slavery has raised a political, social and economic dilemma which until now has not been equitably resolved: the transition from forced free labour to waged labour.' Franck Laraque 'The Relentless Struggle of the Haitian Masses for Liberty and Survival'
http://www.tanbou.com/2005/RelentlessStruggleMasses.htm

4

Peace Brigades International – Haiti Bulletin #7 - July 1997
http://www.peacebrigades.org/haiti/hap97-02.html

5

Eric Verhoogen, 'The US in Haiti: How to Get Rich on 11 Cents an Hour –
A Report Prepared for The National Labor Committee', January 1996
http://www.doublestandards.org/verhoogen1.html

6

Ibid.

7

Ibid.

8

Peace Brigades International – Haiti Bulletin #7 - July 1997, http://www.peacebrigades.org/haiti/hap97-02.html

9

'Rice coming from the United States costs almost half local rice, and a Haitian egg is 50% more expensive than an imported one', Ibid.

10

'The pig's resilience allowed Haitian peasants to raise these pigs with little resources. The peasants characterised their pigs as never getting sick. Creole Pigs served as a type of savings account for the Haitian peasant. They were sold or slaughtered to pay for marriages, medical emergencies, schooling, seeds for crops, or a voodoo ceremony. The resilience and boisterous nature of the pigs, as well as their incorporation into voodoo folklore and the oral history of the Haitian revolution made them a symbol for the independence ... of the Haitian people.' http://en.wikipedia.org/wiki/Creole_Pig

11

Leslie Bagg and Aaron Lakoff, 'Haiti's Deadly Class Divide: Class war takes on a new meaning in Cite Soley',
http://www.infoshop.org/inews/article.php?story=20060
11212511774&mode=print

12

Haiti Information Project (HIP) 'The UN's disconnect with the poor in Haiti', December 25 2005,
http://www.haitiaction.net/News/HIP/12_25_5/12_25a
_5.html

13

'We Won't Be Peaceful and Let Them Kill Us Any Longer - Interview with Haitian Activist', Rosean Baptiste interviewed by Lyn Duff,
http://www.zmag.org/content/showarticle.cfm?ItemID
=9059

14

Letta Tayler, 'Wyclef Jean brings hip-hop hope to Haiti', http://www.hiphoparchive.org/thecircle/?p=520

15

Ibid.

Anthony Iles <anthony@metamute.org> is assistant editor of *Mute*

Since the deposition of Haiti's elected president Jean-Bertrand Aristide in February 2004 the global media, 'civil society' and murderous UN 'peacekeepers' have been working hard to ignore popular demands for his reinstatement, reports Kevin Pina

U.N.-LIBERATING HAITI
by Kevin Pina

For most, Haiti's second name is 'the poorest country in the Western Hemisphere', a well-worn rhetorical device that brings us no closer to understanding the socio-political landscape than reminding ourselves that the United States is the wealthiest and most powerful nation on earth. Yet there they are, the two extremes of wealth and poverty in the western hemisphere inexorably caught in a deadly dance. On one side there is Washington's policy of protecting Haitian elites through a myriad of NGOs hell bent on 'enhancing democracy', and, on the other, close to a million economically dispossessed people able to paralyse the capital at the drop of a hat. It is this dynamic that continues to define the political landscape and the ongoing battle between US foreign policy objectives and the majority of the Haitian people.

That was exactly the dynamic in play when hundreds of thousands of supporters of ousted president Jean-Bertrand Aristide took to the streets to beat back the attempt by the UN/US-backed Provisional Election Council to steal recent presidential elections from René Préval through fraud. Their protests also combined with the results of the elections to expose the big lie that was used as the pretext and justification for Aristide's removal from office – a key piece of misinformation that continues to confuse those watching events unfold in Haiti today.

The overarching thrust of the lie was that Aristide was yet another Haitian dictator in democrat's clothing who had fallen prey to his own thirst for power. His forced departure, and the two years of severe repression that followed, was portrayed as a necessary evil to liberate Haiti from his tyrannical rule. Yet the results of the presidential elections showed that the political parties representing the movement to oust Aristide could not garner a combined tally of more than 30 percent of the vote cast in the elections. Most of these parties polled in single digit numbers exposing what was portrayed as a popular uprising against Aristide for the paper tiger and media creation it actually was. The venerable journalists of the corporate media feed unsuspecting consumers a false image of the strength and numbers of demonstrations against Aristide while virtually ignoring much larger demonstrations like the one on 7 February, 2004. While stories and photos of demonstrations led by sweatshop owner Andre Apaid and his Group 184 chewed up the bandwidth, hundreds of thousands demonstrating

If Aristide had lost the support of the Haitian people, why did hundreds of thousands continue to take to the streets demanding his return?

for Aristide and his Famni Lavalas political party went largely unreported and were treated with indifference by the press.

This also helps to explain the human rights situation in Haiti following 29 February, 2004. If the premise behind the ousting of Aristide was that he had lost the support of the Haitian people, what did it mean when hundreds of thousands continued to take to the streets in a series of endless marches and protests demanding his return? Why were the Haitian police compelled to brutally suppress the demonstrations by firing on unarmed demonstrators as the UN and the international community stood by ready to pounce at the slightest sign of armed resistance to the killings? The answer to those who followed the situation on the ground was simple. Every large demonstration for Aristide's return ran contrary to the to the very justification for his ousting. The US-installed regime of Gerard Latortue, that assumed power with the blessing of the international community following Aristide's deposition, had no choice but to contain this truth through demonising and brutalising the growing protests. While the peoples of the US, Latin

America and Europe were led to believe that the real problem in Haiti was dark and nefarious gangs of killers tied to Aristide, hundreds of thousands of Haitians were risking their lives in almost daily protests where Haitian police with high-powered telescopic rifles would pick them off indiscriminately with a single bullet to the head.

It is no secret that the reason behind Préval's victory was that the base of Aristide's Lavalas party voted for him in overwhelming numbers with three objectives in mind. First and foremost was that they wanted to put an end to the previous two years of human rights hell in Haiti. Summary executions, armed raids and arbitrary arrests took a huge toll on people living in the poorest neighbourhoods of the capital as they continued to resist the US-installed government. Battle fatigue was beginning to set in as these neighbourhoods were forced to continue to fight on two fronts. They managed to fight and resist the brutal Haitian police and the subsequent UN efforts to pacify them, but the time had come to adopt a new strategy. Préval's entering the race, after the corrupt Provisional Electoral Council blocked the

candidacy of the Lavalas favorite Catholic priest Gerard Jean-Juste, provided another avenue around the US and its now famous chorus a.k.a. the international community. They also calculated that the quickest way to insure Aristide's return and secure the release of Lavalas political prisoners was to elect Préval president. That is why, when the fraud in the elections became apparent, they were willing to give the international community an ultimatum: either let Préval win the first round of balloting as initially projected by the polls or risk the country breaking out into civil war with the Haitian police and the UN battling the majority of the population in the streets.

The US and their allies in the Haitian elite and the international community blinked. In an obscure agreement dubbed the 'Belgium option', the international community brokered an arrangement with the Provisional Electoral Council (CEP) where thousands of blank ballots were distributed evenly among the candidates giving Préval the votes he needed to rise above the 50 percent threshold to avoid a runoff. The arrangement also helped to mask the failure of the international community to sponsor clean and fair elections in Haiti after investing an estimated 76 million dollars as well as providing a UN army for security and logistical support to the process.

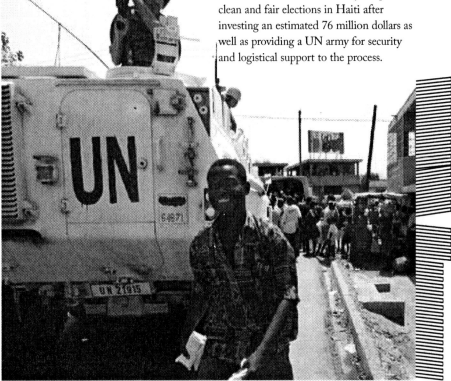

Image: Soldiers distributing food in Port-au-Prince, Haiti, 2006. UN, http://www.un.org

Central to the current struggle between the wealthiest nation on earth and the poorest nation in the western hemisphere is this very question of the return of Aristide. By now it is public knowledge that the US and its closest partners in Haiti, France and Canada, have made it clear that Aristide is not welcome back. The Haitian people thwarted the plans of the CEP to defeat Préval through manipulation and fraud, yet the international community still managed to blame the victim and turn it to their advantage. Then acting US Chargé d'Affaires, Timothy Carney, reminded the new president that a veritable Sword of Damocles hangs over his head. In an Associated Press article written by Stevenson Jacobs on 19 February, 2006 – titled 'American: Haiti Leader Must Perform' – Carney stated, 'If he [Préval] doesn't perform, yes it [the electoral settle-

ment] could weaken him.' Carney then added the caveat, 'If he does perform, nobody will remember it.' Carney had already made it clear that part of the expected performance from Préval included not allowing Aristide to return to Haiti. In a statement the day after the elections Carney said, 'Aristide is on his way to becoming as irrelevant to Haiti as Jean-Claude [Duvalier], and with no future. Aristide is now demonstrated to be a man of the past.' They have also made it clear to Préval that if he even considers allowing Aristide to return he can expect the sharp end of a lance.

In spite of threats by the US and its allies, a demonstration estimated at well over 50,000 took place this last Saturday [article submitted 17 July, 2006] in Port-au-Prince demanding once again that Aristide be returned to Haiti. One of the main

Images: Cité Soleil, Anne E. Shroeder, http://www.language-works.com/

themes of the demonstration was that Préval had been elected for the express purpose of returning Aristide and releasing political prisoners still held in Haitian jails today. Despite protesters forcing their way past armed policemen to march in front of Haiti's National Palace, there was no reported violence and it is expected that this movement will continue to grow in volume and frequency over the next few weeks and months. If the recent past is any indicator, it is only a matter of time before the negative propaganda machine, fed by certain foreign embassies and the local elite, goes into hyper-drive once again to demonise and marginalise the protesters. Then you can expect violence and it will, as always, be blamed on the supporters of Lavalas and Jean-Bertrand Aristide.

the lie was that Aristide was yet another Haitian dictator in democrat's clothing who had fallen prey to his own thirst for power

Kevin Pina <kevinpina@yahoo.com> is a freelance reporter

TOURIST by Félix Morisseau-Leroy

Tourist, dont take my picture
Don't take my picture, tourist
I'm too ugly
Too dirty
Too skinny
Don't take my picture, white man
Mr. Eastman won't be happy
I'm too ugly
Your camera will break
I'm too dirty
Too black
Whites like you won't be content
I'm too ugly
I'm gonna crack your kodak
Don't take my picture, tourist
Leave me be, white man
Don't take a picture of my burro
My burro's load's too heavy
And he's too small
And he has no food here
Don't take a picture of my animal
Tourist, don't take a picture of the house
My house is of straw
Don't take a picture of my hut
My hut's made of earth
The house already smashed up
Go shoot a picture of the Palace
Or the Bicentennial grounds
Don't take a picture of my garden
I have no plow
No truck
No tractor
Don't take a picture of my tree

Tourist, I'm barefoot
My clothes are torn as well
Poor people don't look at whites
But look at my hair, tourist
Your kodak's not used to my colour
Your barber's not used to my hair
Tourist, don't take my picture
You don't understand my position
You don't understand anything
About my business, tourist
'Gimme fie cents'
And then, be on your way, tourist.

By Félix Morisseau-Leroy, translated
from Haitan Creole by Jack Hirschman

TEXT I by Josaphat-Robert Large

In the morning's mirror
The day proceeds step by baby step
 When the dust of the sun smudges the horizon

In the heart of all people in Haiti
Hope lifts anchor

On the open-market's web
Our spirit yearning for bits of inspiration
We're resolving our misery's quandary
And all flowers that have sadly lost their fragrance
Are returning to the nests of their buds

Many minutes slide down
Onto a dawn that stands broken-down
 In the focal point of the sky
A big clock's dancing in folkloric rhythm
To force the dew to flow into leaves

Children are fooling around with the wind
Unwrapping the rope of hopes
 In the air
They are flying toward the moon
 With their kites
And what we take for beautiful trust
 In our consciousness
Are the drawings of the garden we'd want to
Sketch into life
When the morning's mirror
Pitches out its fragment of shadows
Oh, say!
Will the land lift its head again
Oh! With elegance
Will the sunflower finally rise?

TEXT III

Where did that death come from?
Circling the border of existence
Whence did that mourning emerge
That weeds out life in the garden of the future

The street develops a sorrow
 This long!
All houses are painted the colour of distress
Desolation spreads over all the walls
Alongside all the sidings of farmhouses
It hacks up the cornfields of our heart
Sorrow's a pair of scissors shearing our hopes
Cutting our spirit into tiny pieces

Birds high up trace a curve 'round the sun
Windmills are turning the wheels of the sea
Chicken-nests flourish on city's pillars
Thatched houses seem like bones on mountaintops
Where people act like toy soldiers at
 Attention!
Their faces bathed in a mist of sadness
Wind balancing on their heads
Women are mountaineering toward
 The moon
Keeping perfect symmetry between
Their waists and
 The road
They are throwing themselves in front
 Of their existence
Throwing their beliefs in the direction of
 The stars
Oh, friends,
Looting bedbugs are plucking our patience
Plundering our lovely cherry garden of light

Oh, friends,
Poverty hangs itself on our country's luggage rack
Desolation is rolling across all mountains and over all plains
Trying to slow down the wheel of our resistance

TEXT XXIX

A hurricane slaps at the stars
And a downpour of lightning strikes the universe

People in the corridor of their existence
Start yelling for help!
Children break into a run
Birds dash at high speed toward
 The centre of a falling star
The wind lifts my town high up
 And dashes it to the ground
Houses break into tiny pieces
The church crumbles and spreads over the waterfront
 Streets tumble into ravines
People!
The wind has killed God the Father
Everyone on their knees
Let's telephone the Virgin Mary
Hello, Jesus, Hello, Mary!
Where does this fire of wind come from?
That is burning our souls
Wind turning hope upside down
Murdering our common sense
Strangling our patience
Throwing our lives
 Into the abyss
People!
There's a pile-up of wind on top of Central America
Where trucks are lying wheels in the air
A pile-up of tornadoes embracing the earth
Throwing stars around God's spiritual houses
People!
A shard of a bottle tears the face of St. George
Werewolves bite the butt of a butler
Dust mixed with rock stones the moon
People!
The wind's blowing on our hearts
The rain's scattering the sorrow inside us
All the fires are dying in the stars
Life has surrendered to the attack of the rain
And the hurricane is coming back
With its pile-up of abysmal
Wind

Poems taken from *Keep On Keepin' On*,
by Josaphat-Robert Large, translated
from Haitian Creole by Jack Hirschman
with the participation of Boadiba:
iUniverse Incorporated, March 2006

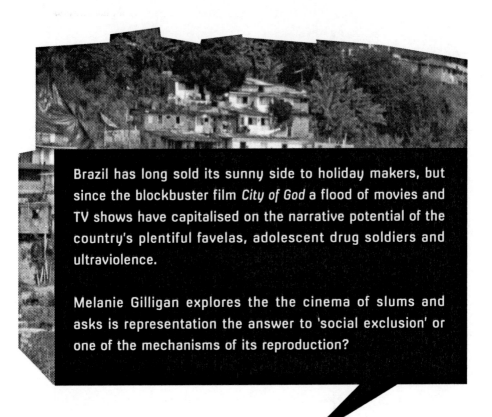

Brazil has long sold its sunny side to holiday makers, but since the blockbuster film *City of God* a flood of movies and TV shows have capitalised on the narrative potential of the country's plentiful favelas, adolescent drug soldiers and ultraviolence.

Melanie Gilligan explores the the cinema of slums and asks is representation the answer to 'social exclusion' or one of the mechanisms of its reproduction?

SLUMSPLOITATION: THE FAVELA ON FILM AND TV
by Melanie Gilligan

The Brazilian documentary *Bus 174* by José Padhila opens as we swoop over Rio de Janeiro's *favela* covered hills. Dramatic aerial shots of Brazil's vast slum cities are a common gambit in the country's burgeoning output of films depicting its *favelas*, crime and poverty. These top-down vistas economically communicate an incalculably vast scale of privation. *Bus 174* chronicles the hijacking of a public bus in Rio in 2000 by one ill-fated resident of the slums. Broadcast live on TV, the hijacking achieved record viewing figures and ended when the police murdered its protagonist. This incident constituted the intersection of two major forces of daily life for Brazil's working and wageless classes: television and state violence.

The hijacker, Sandro, was a former street kid, and had sur-

vived the infamous Candelaria massacre in 1993 when police fired on 70 children sleeping rough in front of a church, killing eight. Throughout the hijacking, Sandro shouted at the police and media, reproaching them for the Candelaria massacre and the violent oppression in the *favelas*. The film presents the hijacking as Sandro's desperate plea for recognition from 'Brazilian society', a desire supposedly felt by the whole of the so-called 'invisible' class living in the *favelas* and streets of Brazil.

The alleged renaissance of Brazilian cinema seems dedicated to answering *Bus 174*'s plea that the country's disenfranchised be represented. Brazil's *favelas* have enjoyed 'increased visibility' with films like *City of God* and have played a lead role in the 'sudden stardom' of Third World slums in First World cinemas.[1] With its nearly unrivalled economic inequality and 51.7 million *favela* inhabitants, the nation has ample material to feed a growing market for depictions of its poverty, crime and economic polarisation.[2]

While a decade ago Brazil's government rented New York museums and private galleries for exhibitions of Brazilian art in an effort to improve its international image of inequality and crime, nowadays the national media have discovered that mining the entertainment value of its 'social problems' produces popular film and television commodities for both the domestic and global market.[3] Many of these unabashedly portray the brutal preconditions and results of the country's extreme disparities in wealth, even criticising this situation through the mouths of their characters. However, they 'raise awareness' only to support the underlying economic conditions. At the same time Lula's culture minister, Gilberto Gil, promises to foster the creative industries, calling them the new motor for Brazil's 'developing' economy, and places the movie business atop his list of creative messiahs.

The internationally distributed Brazilian films we see today are products of increasingly commercial imperatives. All government-funded programmes supporting the Brazilian film industry were cut in 1991. Subsequently, the 'Audiovisual law' was created in 1993 to subsidise private investment in the film industry by granting the immensely wealthy corporations of the world's eleventh largest economy the right to invest up to 70 percent of their yearly income tax in film. The intention was to foster private investment in the film industry so that, when this initiative was phased out in

2003, corporations would continue financing films. The credits of any internationally exported Brazilian film like *Lower City* or *City of God* list some of Brazil's biggest multinationals, namely Petrobras, many banks and of course Globo, the monopoly running 60 percent of national media. Unsurprisingly, this new imperative to yield a high return on investments ushered in an era of increasingly mainstream and Americanised film-making.

City of God, directed by Fernando Meirelles and co-directed by Kátia Lund (2002), epitomises the manner in which Brazil's urban poverty is currently being projected. The film employs a style of fast cutting, abbreviated exposition, tinted colour palettes and perpetually moving handheld photography; techniques which have undeniably become a reified visual 'pre-set' for representing Latin American experience below subsistence level. *City of God* restages epochal class conflicts as a series of personal narratives, beginning in the 1960s when the military dictatorship 'cleaned up the city' for the rich via slum evictions and real estate development.[4] Adapting the technique of first person commentary deployed in Scorsese's crime epics *Casino* and *Goodfellas*, the film's narrator Rocket, a young black *favela* resident relocated to the *City of God*, obscures the

Image: *Bus 174*, directed by José Padilha, 2002

political significance of his eviction by giving the cause as flooding and 'acts of arson in the slums'. We then skip forward to the 70s, the years the *narco-traficantes* gained control in Rio's *favelas*.

While *City of God* renders most of the substantive history in quick strokes, favouring commercially-driven, spectacular vio-

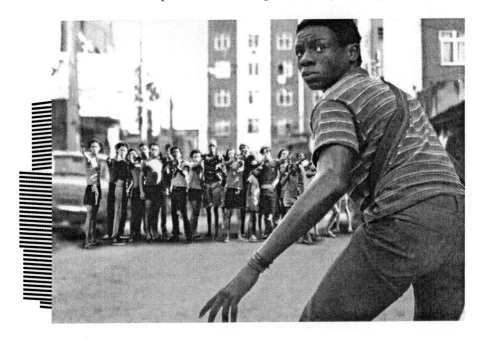

lence, more detail about the political formation of Rio's gangs is given in the DVD documentary 'special feature'. It tells us that widespread arrests of political dissidents during the military dictatorship of the Medici administration 1969-74, landed insurgents in a maximum-security prison with so-called 'common criminals'.[5] This is the popular legend of how educated middle class political prisoners radicalised the working class inmates who then began a movement to self-organise against the systemic violence and deprivation imposed by the state, giving birth to Rio's powerful drug gang Comando Vermelho (Red Command).[6]

William da Silva Lima, one of Comando Vermelho's founders, said the group 'was not an organisation but, above all, a

Image: *City of God,* directed by Fernando Meirelles and Kátia Lund, 2002

City of God rewrites the historic class conflicts in which it is set as a series of personal narratives

kind of behavior, a way of surviving in times of adversity.[7] The soon-to-be Comando Vermelho, known as *o colectivo*, was reintroduced into the larger prison, spreading an ethos of collective organisation. This laid the basis for the contemporary gangs, which today form 'parallel polities' in the *favelas* and prisons, supplying people with essential resources withheld by the state. Soup kitchens, daycare centres, and money for medicines, as well as brutally enforced security, form part of this alternative welfare and justice system adopted by populations disdained and abused by the official state. By some accounts, the drug gangs are businesses, providing services in return for the support of the *favela* communities, 'accomplices of the bourgeois state' that couch their endeavours in politicised rhetoric while obstructing the possibility of organised working class political action.[8] It may be that gang strikes on the middle class areas of Rio have replaced, and contained, what previously manifested as direct working class antagonism – for instance the riots of the late 1980s in which residents of the slum Rocinha attacked a nearby wealthy district.[9] Furthermore, the well-known cooperation between the Brazilian state and the state-like drug gangs – i.e. the police, ostensibly fighting the drug trade, sell weapons to the gangs and are involved in drug transactions with them. This symbiotic relationship goes far beyond individual police corruption and says a great deal about the dependence of the state and ruling classes on the continuation of the drug trade.

City of God's popularity in Brazil lead to a TV drama spin-off called *City of Men*, attempting the same handheld documentary 'gritty realism' in a modern-day Rio *favela*. The first TV drama set in the *favelas*, it was shot in slums like Rocinha, Rio's largest, and watched by 35 million people in Brazil, spawning several other *favela* soaps. The protagonists amaze audiences with their resourcefulness and entrepreneurial zeal, getting

The contemporary gangs form 'parallel polities' in the *favelas* and prisons, supplying people with essential resources withheld by the state

themselves out of the tight spots and near death experiences that living in a community regulated by arbitrary violence creates. In other words, it celebrates the slum as a dangerous but creative place where people improvise solutions.

Critical moments do occur intermittently in *City of Men*. A protagonist leaves the *favela*, telling us he is crossing the frontier between two countries and the police are the border guards. Later he says, 'the playboys (i.e. middle class) watch the slums on TV and think it's better to live where they [the playboys] are. They only come here to buy drugs or make documentaries and films. They need drugs to live there with all the cameras and bars.' Yet one is struck by the way the programme mitigates the force of its own content. After focusing on the lives of *favela* kids for a few episodes, a middle class character is introduced as point of identification and reemployed in increasingly unlikely scenar-

ios. Ostensibly focused on the lives of *favela* dwellers, the show incessantly revisits their relationship to the middle class. A day at the beach is loaded with class tensions, while another episode compares the lives of a young 'playboy' and the working class protagonist, finding the former gets a bit depressed, the latter starves, but the moral is that they both share the same existential angst!

In the guise of offering 'positive representation' to 'socially excluded' residents of the *favelas*, exposing the economic and racial segregation they experience, the show transparently attempts to manage class tensions and assuage middle class guilt. (One candidly propagandistic episode narrates the legend of Lula's working-class childhood, offering a 'working class' hero as point of identification for those viewer's not feeling sufficiently 'represented' already). If any viewer doubts the importance of being portrayed on the

channels of the nation's most powerful TV monopoly, Globo, the recurrent shots of densely clustered satellite dishes atop *favela* shacks drive the point home.

City of God contains similar nods to the Brazilian media's might – gang members compete to get their photos in the newspapers, while TV and news journalism are recurring motifs. During the 1960s and '70s the military dictatorship fostered a powerful television dominated 'culture industry' as a means to cohering national identity, promoting consumerism and controlling the political sphere. The television monopoly Globo governed official public discourse in Brazil, as the right hand of the dictatorship until its end in 1984, and has been influencing political outcomes, electoral and otherwise, ever since. *City of Men* supplements its documentary aesthetic with mock TV news interviews, while a media circus is *Bus 174*'s starting point for discussing life on the streets and in prison. The fascination with mediation in these films may reflect more than just the spectacularisation of daily life. Perhaps it is also an index of the self-consciousness of an industry that has long exploited the frisson of *favela* culture and violence. However, placing the interdependence of Brazil's official 'cultural' and 'informal' or illegitimate economies in plain sight could seem to cynically reinforce its inevitability.[10]

The monolithic media of Brazil presents a means for liberal audiences to reconcile themselves with the brutality of state repression against the working class. Despite the intention of exposing state violence which informs films like *Bus 174* and Hector Babenco's *Carandiru* (2000), these films' critical challenge to the present order is blunted into a kind of empathic supplement to its brutality. *Carandiru* tells the story of the infamous 1992 massacre in a Sao Paulo prison. Police, called to quell a riot, killed 111 unarmed prisoners. Numerous inmates were murdered execution-style, some several hours after the riot was suppressed. This extermination returned to haunt the gated 'communities' of Sao Paulo this May when the Primeiro Comando da Capital (PCC) gang formed in response to the massacre and sworn to avenge it, declared war on the state, starting 75 separate prison riots and attacking the stations, cars and homes of the police.[11]

Like the Comando Vermelho, the PCC constitute a parallel, if illegitimate, state controlling 90 percent of the prison system in

the state of Sao Paulo and even funding their own electoral candidates. Each member swears to a manifesto-like list of statutes which pledge unceasing struggle against the injustices and oppression inside prisons, solidarity with and support for all members and to be the 'Terror of the Powerful oppressors' who run the prisons. Apart from participating in all manner of organised crime, the gang have also 'reduced the level of violence (in prisons) … won better visiting rights … (paid) for coaches of family members … and … defense lawyers for their members'. The PCC has allied with Comando Vermelho (responsible for prison bloodbaths of their own, however) to strengthen their influence on the nation's prison system.[12]

Although Rio gangs have conducted many similar attacks, the scale of the PCC's actions and their unequivocal demands for prison reform potentially indicate a more developed political agenda. After the PCC shut-down the country's richest city and threatened the heavily guarded safety of the ruling elite and killing 40 police officers, the police repeated the violence of Carandiru randomly shooting people in the *favelas* and sending 'death squads' during the following week. The police suspiciously revised the total civilian body count down from 109 to 79, of whom 34 are acknowledged to have been killed by death squads.[13]

Image: *Carandiru*, directed by Hector Babenco, 2003

Melanie Gilligan

The media allows liberal audiences to reconcile them- selves with state repression against the working class

Bus 174 also presents images of the prisons and the appalling conditions endured by the likes if Sandro, the hijacker, in the years prior to the incident. His cell used to be 40 °C and so packed that half the inmates stood so that the other half could sit. Later, prisoners in cramped cells denounced the state's negligence, corruption and injustice. Once again the film's premise is that Brazil's street kids and *favela* inhabitants want desperately to be represented and recognised in Brazilian society. This view is explicitly stated by Luis Eduardo Soares, Rio's former subsecretary of public security, in an interview that is interspersed throughout the film. Audaciously, Soares asserts that this need for acknowledgement is the biggest problem facing street kids today (not hunger or getting shot or brained with rocks while asleep!). This position

resonates with the strategy of *City of Men* and indeed on a macro level with Brazil's attempted conversion to a culture economy. In other words, represent the working class in the media and hopefully demands for economic parity will decrease.

The director claims that the film reopened debate about the hijacking, this time creating discussion about the reasons for Sandro's action, instead of vilifying him as a drugged-up hoodlum. However, without addressing the basic *material* needs of the population and curbing the murderous domination of the police-gang state repressive apparatus such debate is likely to remain sterile.

Brazilian culture minister Gilberto Gil proposes that increased production of cultural exports will bring prosperity to Brazil, stating that global revenues generated by the 'creative industries' will be 1 trillion 300 billion US dollars this year.[14] Culture in the *favelas* has long been profitable. For instance, samba, once a central part of *favela* life, was turned into a mainstream commodity and official national culture. Today samba's social function in the *favelas* is mostly fulfilled by 'Baile Funk', itself an increasingly popular cultural export. A recent investor-oriented *Financial Times* article spoke of the atmosphere in Rocinha as 'like stepping into the tempting chaos of a rock concert' indicating that Rio's *favelas* are gaining a reputation for edgy culture that could attract many more such capitalisations. Gil encourages Brazilians to become cultural producers. We hear the same message in *Favela Rising*, a documentary by

American filmmakers Matt Mochary and Jeff Zimbalist, which zealously deploys the now formulaic MTV-povera aesthetic of *City of God* (etc). Once again, a collective story about community music group *Afro Reggae* becomes the tale of one man, Anderson Sá, and his fight to improve life in the *favelas*. Interviews with Sá carry a clear message – he preaches the salvation of cultural work as the way to pull oneself out of the slums. Artists have long been considered able to transgress class barriers, but it is unlikely that all the kids Sá would like to save from becoming drug soldiers could become middle class creative workers. The economic situation in Brazil would not allow for it. Incidentally, the message of *City of God* is quite similar – Rocket 'gets out' precisely because he is lucky enough to land a job as a photographer on the basis that he can get close to the gang action in the *favelas*. Thus the hypothetical lucky ones become cultural workers that subsist by documenting the lot or selling the culture of the unlucky.

Despite the creative economy line being fed by the Lula administration and the production of new rags-to-cultural-work-riches films, (such as recent release *2 Filhos de Francisco*, the biggest hit at Brazilian box offices in 20 years) those living in *favelas* will continue to be portrayed in cultural commodities but are unlikely to benefit from their production. Furthermore, the box office and broadcast hits bringing *favela* life to middle class Brazilian and western audiences are taking place in a context of growing eco-nomic disparity and a 'drastic diminution of the intersections between the lives of the rich and the poor'.[15] Sao Paulo's 300 hundred gated communities serviced by the world's highest civilian helicopter traffic, or the Rio government's plan to build a 7 foot wall around several *favelas* push the working class further out of sight.[16] As material segregations proliferate in the cities of Brazil, it seems unlikely that the new market for consumer-friendly representations of the *favelas* will lead to anything more than profits off the backs of those who are, so to speak, providing the content.

Footnotes

1
Rana Dasgupta, 'The Sudden Stardom of the Third-World City', http://www.nettime.org/Lists-Archives/nettime-l-0603/msg00031.html

2
The richest 10% of Brazil owns between 48% to over 50% of the nation's wealth while the poorest 10% own 1%.

3
Barry Schwabsky, 'Art from Brazil in New York', *Artforum*, Summer, 1995, http://linkme2.net/9j

4
'Evoking the threat of a tiny urban *foco* of Marxist guerillas, the military razed 80 favelas and evicted almost 140,000 poor people from the hills overlooking Rio. With financial support from USAID, other favelas were later demolished to clear the way for industrial expansion or to "beautify" the borders of upper income areas. Although the authorities failed in their goal of eliminating all "slums within Rio within a decade", the dictatorships ignited conflicts between bourgeois neighbourhoods and the favelas, and between the police and slum youth, which continue to rage three decades later.' Mike Davis, *Planet of Slums*, Verso, London, p. 108.

5

In Brazil today '98% of prison inmates lived in poor or modest economic conditions prior to their arrest'. Marie-Eve Sylvestre, 'Crime, Law & Society – Exploring the Relationship Between Crime, Punitive Practices, Poverty and Social Exclusion in Contemporary Societies', Harvard Law School, http://www.law.harvard.edu/academics/graduate/sjd_ca ndidates/marie-evesylvestre/syllabus.doc

6

'Conditions in the prisons included systematic torture and no basic amenities (mattresses, linens, blankets, soap)', Elizabeth Leeds, 'Cocaine and Parallel Polities in the Brazilian Urban Periphery: Constraints on Local-Level Democratization', *Latin American Research Review*, Vol. 31, 1996, p.54.

Comando Vermelho orchestrated a series of attacks on Rio's middle class neighbourhoods during the same week that *City of God* won the BAFTA for best editing. The gang told the press they were retaliating against 'oppressive and cowardly' policing in the slums and politicians' violence against the poor. Would this also qualify as a plea for recognition? 'Rio gangs cast violent shadow over carnival', *The Guardian*, http://www.buzzle.com/editorials/2-25-2003-36272.asp

7

Elizabeth Leeds, op. cit., p.54.

8

Hector Benoit, 'Brazil: The social contradictions underlying the violent eruption in Sao Paulo', World Socialist Web Site, May 2006, http://www.wsws.org/articles/2006/may2006/braz-m18_prn.shtml

9

Elizabeth Leeds, op. cit., p. 48-49.

10

The treasure trove of eye-witness reports from the *favela* front lines have recently proven dangerous business. In 2002, celebrity reporter Tim Lopes, renowned for his undercover work, often in disguise, was dismembered with a samurai sword and burned during a *favela* reconnaissance. Tom Phillips, 'Justice for One. In Brazil, Drug War Goes On', *Brazzil Magazine*, June 2005, http://www.brazzil.com/content/view/9297/79/

11

Gibby Zobel, 'Mayhem That left Sao Paolo in Shock', *Al Jazeera*,

http://english.aljazeera.net/NR/exeres/B0DB410F-55C4-4A73-8EAF-41475DD8CF7B.htm and Pepe Escobar 'The accumulation of the wretched, a review of *Planet of Slums* by Mike Davis', http://www.atimes.com/atimes/Front_Page/HE20Aa01 .html

12

Tom Phillips, 'Jail riots kill up to 80 as gangs rebel', *Sunday Herald*, June 2004, http://www.sundayherald.com/42704

13

'Brazil: Death tally reaches 400 in the wake of attacks in Sao Paulo State', *Coav Newsroom*, http://www.coav.org.br/publique/cgi/cgilua.exe/sys/start.htm?infoid=1956&tpl=printerview&sid=114 and 'Brazil probes police role in gang riots', *Al Jazeera*, http://english.aljazeera.net/NR/exeres/F418DB9E-5DEE-4B18-A9FE-F11A9FA76863.htm

14

Tiffany Linton Page, 'Building a Creative Utopia in Brazil', Center for Latin American Studies, February 2005, http://www.clas.berkeley.edu:7001/Events/spring2005/0 2-17-05-gil/index.html and *Washington Post*, http://www.washingtonpost.com/ac2/wp-dyn/A42332-2002May31

15

Mike Davis, *Planet of Slums*, Verso, London, p. 119.

16

Anthony Faiola, 'Brazil's Elites Fly Above Their Fears Rich Try to Wall Off Urban Violence', *Washington Post*, May 31st 2002, http://www.washingtonpost.com/ac2/wp-dyn/A42332-2002May31 and Daniel Howden, 'Bitter Divide over Plan to Wall in Rio's Slums', *Independent*, June 23, 2005, http://www.amren.com/mtnews/archives/2005/06/bitter_divide_o.php

Melanie Gilligan <megili@hotmail.com> is a writer, artist and filmmaker. She also sings in Petit Mal and Antifamily http://www.difficultfun.org/items/petitmal.html, http://www.antifamily.org

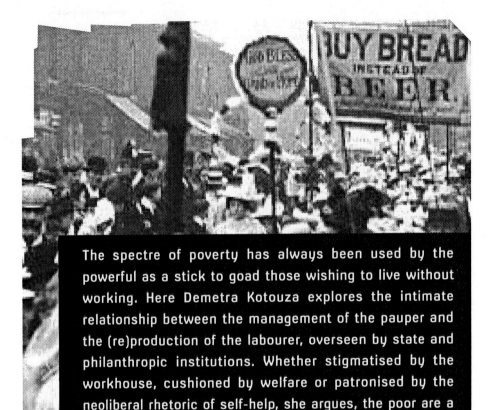

The spectre of poverty has always been used by the powerful as a stick to goad those wishing to live without working. Here Demetra Kotouza explores the intimate relationship between the management of the pauper and the (re)production of the labourer, overseen by state and philanthropic institutions. Whether stigmatised by the workhouse, cushioned by welfare or patronised by the neoliberal rhetoric of self-help, she argues, the poor are a necessary constant of capitalism

LIES AND MENDICITY by Demetra Kotouza

Image: The Manchester
Band of Hope on a tem-
perance march in 1901

T he commonly made observation that neoliberalism represents a return to the Victorian era, though sometimes betraying a nostalgia for social democracy, nevertheless has an empirical credibility. Similarities between Adam Smith and Milton Friedman, the workhouse and workfare, slum clearance and regeneration, the recruitment of working class missionaries by philanthropists and of 'social entrepreneurs' by contemporary charities, all bear witness to the continued relevance, if not 'return', of Victorian practices. Rather than an atavistic reversion to an outdated system of economy and governance, however, such parallels reveal the persistence of a problem faced by capital and the state: that of the production, management and moulding of propertyless populations in the most profitable way. Shifts in the administration of poor relief in early 19th century Britain, and subsequent philanthropic interventions, bear a resemblance to changes taking place today. Beyond a mere analogy, this entails an actual reappearance of private charity in the management of poverty, its Victorian inspiration explicitly acknowledged by ideologists and politicians for charity's supposed capacity to become the 'other invisible hand' that can eliminate 'social exclusion'. An examination of such changes shows that history is not merely repeating itself, but rather that these policies, techniques and practices, no matter how crude, subtly invasive or seemingly benign, have never been separable from capital's need to reproduce itself.

The first quarter of the 19th century revealed the inability of the centuries-old parish poor relief system to cope with the degree of poverty and mass flight of dispossessed peasants to the cities entailed by enclosures, mechanisation and the monetarisation of labour. 'Old' Poor Laws were held responsible, in the 1833 Poor Law Commissioners' report, for a demoralisation in the labouring classes that not only disturbed labour market equilibrium but also caused social unrest. The old Poor Laws were

> a check to industry, a reward for improvident marriages, a stimulant to population, and a blind to its effects on wages; a national institution for discountenancing the industrious and honest, and for protecting the idle, the improvident and the vicious; the destroyer of the bonds of family life; a

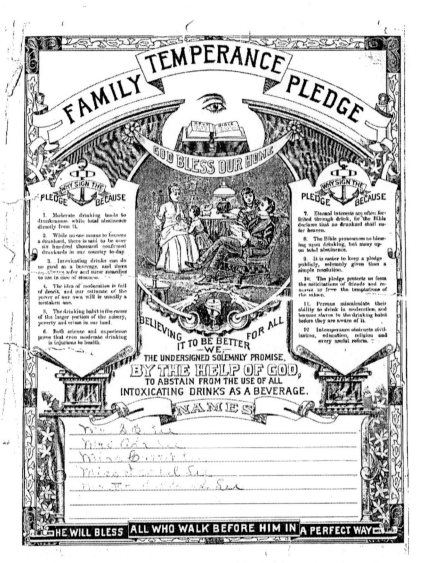

system for preventing the accumulation of capital, for destroying that which exists, and for reducing the rate-payer to pauperism; and a premium for illegitimate children in the provision of aliment.[1]

The 1834 Poor Law Amendment Act was designed to convert 'paupers' into 'independent labourers' by making relief conditional upon entering a workhouse where conditions would be so unbearable as to deter everyone but the most desti-

Image: This poster comes from a temperance campaign in the USA

Charities, savings banks and friendly societies became crucial to the governmental aim of exerting influence over poor households

tute and infirm. Although some 2000 workhouses were already in operation by the late 18th century, these institutions were managed locally, and had mostly ended up functioning as geriatric wards and orphanages with a parallel system of outdoor relief for the 'able bodied'. The new law reinstated and standardised their disciplinary function by banning outdoor relief and transferring ultimate control to the state. Inspired by Malthusian prescriptions on restraining the number of 'supernumerary' populations and Benthamite notions of rewards and punishments, the liberal government was not merely interested in unconditionally fostering the population. It had to achieve 'security and prosperity for the greatest number' in the most cost-effective way, meaning that it would no longer give 'legal status to inferiority'.[2] The survival of such inferiority was then to be excluded from legal providence, while its continued existence was necessary for the maximisation of 'independent labour'.

Workhouses were to be institutional spaces of extreme poverty; but with life outside often already below subsistence levels, and since inmates had to be kept alive, a harsh disciplinary regime was imposed to frighten away everyone who had the slightest prospect of life. Those desperate enough to enter the 'Poor Law Bastilles' were segregated into yards to prevent procreation or the corruption of children by their parents, and were subjected to the penallabour of breaking stones and picking oakum.[3] While not prescribed by the Law, the forms of violence routinely inflicted on inmates included long-term incarceration, withholding food, neglecting severe wounds and illnesses, placement of the sane in insane sections, and rape. These punishments were often fatal. A series of cases publicised by workhouse inspectors shocked the bourgeois public with the 'lawlessness' that reigned in those spaces.[4] This lawlessness, however, had been instituted in the workhouse by the New Poor Law itself, with its implication that inmates did not

deserve to live. As Engels observed, '[i]f the law in its essence proclaims the poor criminals, ... beyond the pale of the law, beyond the pale of humanity, objects of disgust and repulsion, then all commands to the contrary are unavailing'. Workhouse thanatopolitics may appear extreme and irrelevant to contemporary forms of workfare, but its legacy can be seen in the punitive nature of such schemes, where punishment is the strategic withdrawal of the means of subsistence.

The Malthusian fear of the uncontrollable geometrical increase of pauper populations could not just be alleviated by removing obstacles to premature mortality in the lower classes for the sake of the species survival. Preventive birth control measures were also needed which involved education outside the workhouses. The introduction of the New Poor Law then aptly coincided with a renaissance in a new type of philanthropic organisation which had rejected the idea of almsgiving, elaborating a variety of techniques by which to create a fit between political economy and the population. Charities, savings banks and friendly societies became crucial to the governmental aim of exerting influence over poor households in such matters as frugality and industry, foresight in marriage and reproduction, the education and discipline of children, hygiene, and philanthropic engagement. It is telling that the 'voluntary impulse' romaticised today by policy entrepreneurs such as Tristram Hunt and Geoff Mulgan did not condemn the institution of the workhouse, but rather wanted to expand the reach of its 'reformative function' to the private lives of poor families and individuals.

The Victorian philanthropists' discourse on the poor was largely aligned with that of the liberal state. 'Illegal' workhouse violence was reproached, but much more worrying was the fact that despite that violence workhouses failed to act as deterrents. In 1846 the Charity Organisation Society (COS) – the most influential league of charities up to the 1880s – called for tighter controls in the acceptance of inmates and intervened to make sure that those who entered workhouses were truly 'undeserving'. Officers of the COS and Octavia Hill visited poor households to investigate and reform home circumstances. Imperialist philanthropists proposed exporting the poor to the colonies (W. E. Stead) or transporting them to 'labour colonies' in the countryside (Charles Booth / The Salvation Army), where they would be taught the virtues of productivity without imposing their ugly and burdensome presence on respectable city dwellers. Even certain 'socialist' philanthropists such as Sidney and Beatrice Webb insisted that life that persisted 'in disease and squalor, vice, mendicancy and crime' was guilty of 'infecting and contaminating the rest of the community'. The new wave of philanthropists sought to teach the working class how to reform itself on the assumption that poverty was the result of a series of individual or community produced moral failings. What those failings were is evident from the kind of middle class philanthropic societies that had emerged by 1897. Some examples from the Labour Annual: National Thrift Society; Ladies'

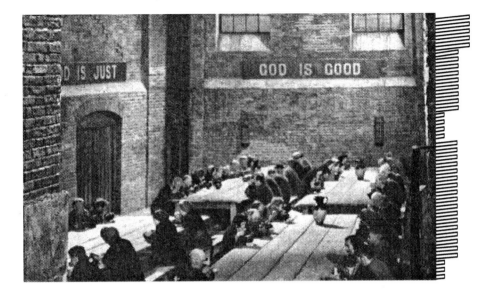

Sanitary Association; The Bible Women (working class women recruited by Ellen Ranyard to advise poor women on domestic economy and sell bibles); London Mendicity Society; National Anti-Gambling League; Band Of Hope (children committed to temperance); and Mary Carpenter's Reformatory School in Bristol for the 'children of the perishing and dangerous classes'. The liberal emphasis on individual responsibility, self-help and independence commanded that the 'dangerous classes' be controlled, managed and reconstructed because 'the proletariat may strangle us unless we teach it the same virtues which have elevated other classes of society'.[5] With the 1870 Education Act, charities were given powers to found thousands of schools and enforce the attendance of children.

In order to maximise the value of home visits and to guarantee consistency, societies also turned the poor into objects of research (e.g. Henry Mayhew, Charles Booth) and promoted the professionalisation of visitors through training and producing guidelines – practices which prefigured the institutions of social work and probation.

The fear that environmental degradation caused crime prompted street clean-ups and the construction of 'model dwellings' which was intended to displace slum residents rather

Image: Workhouse
dining hall

than provide new housing. In the 1870s the solution to overcrowding and unsanitary habitation proposed by COS was compulsory purchase of slum areas and subsequent slum clearance by the Metropolitan Board of Works in London. It was hoped that demolition would disperse the 'worst elements' of the slum population, and when the new buildings were completed, only the respectable surrounding population would be attracted by their better quality and higher prices.[6] This strategy of displacement anticipates the current trend for creating new housing for 'mixed communities' in the place of previously run-down housing estates.

Alongside these bourgeois philanthropic organisations, a number of socialist and working class associations had also

19th century bourgeois philanthropy is the ideal paradigm for contemporary forms of population management, beautified by pseudo-innovative concepts such as 'social capital'

appeared in the 19th century, whose ideology and activities were based on the principle of mutual aid. In the absence of welfare rights – which many of these organisations called for – self-help societies enabled the survival of low-paid labourers in times of hardship or in their old age, while often also becoming instruments for the self-imposition of discipline and bourgeois morality.

19th century charity's 'effectiveness' in keeping the poor alive, 'cultivating community' and promoting 'liberty, personal responsibility and independence' are now lauded by neoliberal organisations such as the Institute of Economic Affairs (IEA) but also by New Labour think tanks such as Demos, as a morally and economically

superior alternative to the welfare state. The similarity between 19th century narratives of the 'root causes of poverty' and their associated philanthropic and intellectual palliatives, and contemporary neoliberal and Third Way discourses on poverty and 'social exclusion' can be explained by the resurgent imperative to remove all alternatives to work and produce self-policing subjects. Inclusion requires everyone – those on incapacity benefit, pensioners, those in care – to rejoin the expanded workhouse: an institution that has never excluded anyone on the basis of age, physical ability, or mental state.

The Poor Law, nominally in place until 1929, was effectively superceded by the introduction of a basic social security system in 1912 which provided unemployment, sickness and maternity benefit. Prompted by the volume of unemployment and impoverishment generated by repeated crises of *laissez-faire* capitalism, and increasing working class pressure both directly and electorally, the British government was forced to make its first concessions, which were to be followed by the massive post-war expansion of the welfare system. The latter was part of an exercise in 'Keynesian' demand management aimed at generating full employment and enabling the working class to consume on a scale capable to sustain production and defuse class struggle. In this context, philanthropy had retained its policing role, with its investigative officers and retraining and reform centres still in operation, albeit at a smaller scale, providing expert knowledge on local 'needs', as the intellectual father of the

British welfare state, Lord Beveridge, had suggested in his tract *Voluntary Action*. However, as the problem of poverty was mostly being managed by the state, and after the 1960 Charities Act which rationalised the supervision of charities and clarified their non-political mandate, charities were reduced to 'covering gaps' in welfare service, while trying to make inroads into the community, often antagonistic to labour organisations.[7]

Thatcher's '80s government delivered the first great blow to state-guaranteed survival for the working class. This was not simply a return to the prerogatives of free markets, but rather a realisation that Keynesian state management had not only failed to create a social equilibrium that would allow markets to thrive, but actually become an impediment to labour markets. With trade unions divested of any power during the consecutive conservative governments in the '80s and early '90s, and with the end of the Cold War, the welfare state had become an unproductive and burdensome bureaucratic edifice, a leftover from the times of compromise.

Thatcherism introduced renewed emphasis on voluntarism and 'active citizenship' with the 1988 Social Fund that was designed to bring charities closer to the state, and a tax reform to encourage donations. However, the proponents of civic capitalism such as IEA complained that 'government with character' and not *laissez-faire* should shape the policy of a truly liberal government, and this meant the active fostering of 'civic virtues', the individual responsibility 'of free agents' and 'mutual

REVOLT

OR, THE

WORKHOUSE

Or, A Night's Hullabaloo !

☞ *This glorious achievement by the Females of the Parish of Shoreditch, has gained the kind feeling of our Authorities, who have most generously complied with their request— All is now restored to Peace and Harmony.*

Mr Diffy, (Head Overseer of the ——————— Workhouse) Mr LEESON
Mr Cauliflower, (a Relieving Officer) Mr W. PHILLIPS •
Mr Bounce'm - (Master of the same) - Mr W. MILBORNE;
Tipstick, a Beadle) Mr JAMES Door-Keeper, Mr STEVENS
Miss Pommoy, - (a Charwoman) - Mrs H. RIGNOLD
Moll Mager, • (a Lady with a Large Family and Small Income) • Mr T. LEE
Sniffling Poll, (an Inmate of the Workhouse) Mrs LOVEDAY
Chaunting Bess, Miss PEARSON Deborah Snuff, Mrs BROOKES
Women, Mesdames Woolfe, E. Earl, Johnson, M. East. Officers, &c.

OVERSEER's ROOM in the WORKHOUSE.

RELIEF DAY. | THE APPLICANTS.
THE OFFERS. | THE REFUSALS.

The Irish Visitor and her Family.

Female Ward in the Workhouse.

Air,—"The Girl I left behind me."

THE ENQUIRY. | THE CONFESSION.
THE COUNCIL. | THE RESOLVE.

The First Break out of the Female Paupers.

A Room leading to the Master's Apartment.

GRAND CHORUS.

BARLEY WATER CHANGED. | TEA GRANTED.
DISCOVERY OF THE RIOT. | DETERMINATION.

Choosing a Speaker. Irish Eloquence.

Open Revolt. Military Preparation. Attack. Retreat of the Enemy.
Final Settlement to the Satisfaction of all Parties. DENOUEMENT.

obligation' that had been eroded by the welfare state. What was needed was a return to 'welfare without politics', that is, Victorian-style private charity.[8] Worse, the conservative strategy of creating labour market competition and eliminating 'lifestyle' unemployment had been unsuccessful, as evidenced by the Poll Tax riots, anti-M11 protests and other upheavals. With New Labour, these 'eroded values' would be regenerated through 'partnerships' with 'communities' and the voluntary sector.

In 1992, before New Labour had come to power, Labour MP Frank Field's statement already echoed 19th century fears about the uncontrollable classes, justifying the impending attack: 'We've got a number of young people here who are outside the labour market, who've created their own world, partly through crime, partly through drugs, partly through drawing welfare, and who are not

Image: Shoreditch theatre poster, 1847. In 1847, a report on workhouse provision criticised conditions in the Shoreditch workhouse (today St. Leanords' Hospital on Kingsland Road). It was found to be overcrowded, its ill inmates packed together with healthy inmates in airless wards, and with poor water supply. The workhouse was soon the subject of a 'Grand Comic interlude' at the Royal Standard Theatre in Shoreditch

prepared to join Great Britain Ltd. again on the terms that we offer.' The punitive New Deal for Young People and Communities was explicitly intended not only to revitalise the labour market by removing all other legal options for survival that strayed from the Gateway to Work, but also to innovate techniques for transforming behaviour. The 'partnership' with charities in the delivery of New Deal training placements was aimed at reducing costs, decentralising governance, and making use of charities' 'local knowledge, resources and experience' in the management of working class youth.

The third sector fits easily into this role. These are officially 'non-political' organisations whose income is derived from middle class and corporate donors, the state and from unpaid labour. The appellation 'non-profit' does not indicate a lack of surplus, but its reinvestment in 'good causes': the production of the organisation's service component of its commodity, which is distributed free or very cheaply. The full commodity, however, that which is sold for revenue and even profit, is the services provided to funders: 'expertise, resources, and knowledge about local need' for governmental funders; and the moral legitimation (and tax relief) of charity for private funders, together with the elimination/reformation of the most dangerous 'pauper' elements. In this sense, their 'patients'[9] active participation is necessary, and valorised in the production of the full commodity, while what they 'get' in return is effectively alms conditional upon appropriate conduct and on-the-job training.

The latter amounts to hyperexploitation by both the charity and the employer who often provides the training: trainees' elusive reward is 'skills', i.e. a *potential* – unrealised and possibly unrealisable, 'enhancement' of their labour power. The charities' function is therefore entirely political and economic, deliberately or inadvertently lending a friendly face to Third Way (neo)liberalism.

American academic Robert Putnam's popular communitarian ideas also prescribe community 'empowerment' through voluntarism, aimed at promoting 'social and political integration', fostering 'trust' between and within classes, and promoting 'socially productive norms' – the ingredients for the creation of 'social capital'.[10] Despite the spurious use of the word 'capital' to describe labour, this scenario is linked to policies intended to create profitable 'community' enterprise that would promote normative behaviour in 'hard to reach' 'socially excluded' populations. Local activists, specially selected for the values they champion (usually 'peaceful integration', 'employment', 'independence', 'self-control', 'civic participation'), mostly targeting unemployed youth and adults, single mothers, black/ethnic groups, and people with 'mental health' problems, are nominated and funded as 'social entrepreneurs' on the condition that their projects will shortly become profitable. This productive moralisation of local life echoes 19th century projects: 'life-skills' training' for the homeless ('more than just a home'), self-help packages to be purchased by parents, savings and debt management education, self-confidence and self-reliance coaching, and good old work training most

frequently in construction, cooking and carpentry. All this is combined with self-policing schemes such as ASBOs, and the charitable donation of broadband and 'community TV' where viewers can watch 'familiar local faces' as they commit crimes, and report them. This is not staged as a solely top-down *dispositif* of the state. Local Strategic Partnerships are all about selectively attending to demands made in the name of 'the law-abiding, long-suffering poor' or by more openly authoritarian 'ordinary people' who cannot stand 'aggressive begging', petty crime and 'drug addicts' and desire to organise against the elements that 'threaten our community', with police support.[11] 21st century mutualism and civic engagement is all about cleanliness and order: 19th century political voluntarism (workers' clubs, organised labour unions, emerging communist and anarchist movements) is perverted in its nostalgic invocation.

On the contrary, 19th century bourgeois philanthropy is the ideal paradigm for contemporary forms of population management, beautified by pseudo-innovative concepts such as 'social capital'. Far from representing altruism, the third sector is pivotal not just for the extraction of surplus value, but for the creation and reproduction of labour, through trying to eliminate any conception of survival not based on selling one's labour power. The reproduction – and suppression – of labour as potential, as 'unobjectified', 'denuded life', 'as absolute poverty', in Marx's terms, has been the historical goal of poverty management. The exceptional nature of the 'victories' of the labour movement in terms of the kind of 'social security' provided by social democratic governments – or, for that matter, the exceptionality of any pledge of a sovereign state to guarantee the right to life for its citizens by providing a minimum income for all – is evidenced by the mere existence of detention centres for propertyless non-citizens. Because of their purported redundancy for capital, as non-objectifiable labour, like Malthusian supernumeraries, outlawed immigrants are thrown into a constant condition of complete denudation in high-security 'removal centres' designed to act as deterrents, while, as non-citizens, they are lawfully excluded from all legal protections. This exception is not the result of a racist neglect attributable to labour movements, but an exception *necessary* to define what it means to be a citizen and to enable the state's own existence, while also defining the extreme lower end of labour stratification on the basis of its (il)legality. The concurrence between absolute poverty as constitutive of capitalism (Marx), and of the state of exception as constitutive of sovereignty (Agamben) is concretised here in the figure of the workhouse, whose principles today are deployed in an expanded scale.

The denuded body of the pauper was not merely a historic precondition for the existence of capital, but has to be reproduced – while repressed at the same time. Poverty poses a danger, both because it produces the compulsion to work, thus giving the lie to any 'free and equal' exchange of labour power for money, but, more importantly, because in its effort to survive as unobjectified labour it contravenes the laws

and disturbs the order of a system designed to guarantee the impossibility of doing so. Unemployment and poverty are therefore reduced, but not eliminated, in order for them to exist as the nemesis of socially and economically 'productive citizenship' whose threatening and pitiful 'condition' calls for punitive and educational humanitarian interventions. ➤

Acknowledgements: Many thanks to Matthew Hyland and Josie Berry Slater for their comments and suggestions

Footnotes

1
Nassau W. Senior and Edwin Chadwick, *Poor Law Commissioners' Report of 1834*, London: H.M. Stationery Office, 1905.

2
De Tocqueville, *Recollections*, 1968/1893.

3
Oakum is a 'loose fibre obtained by untwisting old rope, used especially in caulking wooden ships.' OED.

4
Charles Dickens, *Our Mutual Friend*, London: Chapman and Hall, 1865.

5
Samuel Smith, *The Industrial Training of Destitute Children*, London: Kegan Paul, Trench & Co., 1885.

6
Gareth Stedman Jones, *Outcast London: A Study in the Relationship Between Classes in Victorian Society*, Harmondsworth: Penguin Books, 1984.

7
David Vincent, *Poor Citizens: The State and the Poor in Twentieth-Century Britain*, London: Longman, 1991.

8
David G. Green, *Reinventing Civil Society: The Rediscovery of Welfare Without Politics*, London: IEA Health and Welfare Unit, 1993.

9
In Labour Economics, participation in workfare programmes is frequently analysed using medical methods and terminology such as 'treatment', 'dose' and 'uptake', notably by Nobel laureate economist James J. Heckman.'

10
Robert Putnam, *Making Democracy Work: Civic Traditions in Modern Italy*, Princeton, NJ: Princeton University Press, 1993.

11
Cf. the resident-initiated 'Community Plan to Address Drugs, Street Crime and Anti Social Behaviour' by the Covent Garden & Bloomsbury Community Association http://www.casa.ucl.ac.uk/bloomsbury/www/docs/consultation.pdf

Demetra Kotouza <demetra@inventati.org> is a contributing editor of *Mute*

Whilst in the expanding global slum survival at subsistence level is increasingly the only option, in the West the celebration of the creativity and ingenuity of the slum dweller is becoming fashionable. In a conflation of relational aesthetics with the 'creative' survival strategies of the globalised slum, many artists have become associated with what could be called 'slum chic'. Anna Dezeuze surveys a number of artists who draw upon the experience of everyday life in the slums to make their work, and tries to separate out the aestheticisation of poverty from the poverty of aesthetics

THRIVING ON ADVERSITY: THE ART OF PRECARIOUSNESS by Anna Dezeuze

Anna Dezeuze

W alking around the immaculate spaces of the New York Guggenheim, I once came across a roughly built brick shelter, with two pillars and a roof, and a small shack with a large satellite dish. In an adjoining metal structure stood a single functioning toilet. In the reassuring bubble of an archetypical museum, the images of shanty town architecture and emergency refuges conjured by the basic components of this pared-down construction seemed very remote. The structure in front of me, I was informed by a wall-text, corresponded to an existing type of core unit being built at the time in a far-away location: Kagiso, a suburb of Johannesburg. The artist, the Slovenian Marjetica Potrč, had just been awarded the 2000 Hugo Boss Prize.

Two years later, the Belgian, Mexico-based artist Francis Alÿs was short-listed for the Hugo Boss prize. His *Ambulantes (Pushing and Pulling)*, a slide series executed 1992-2002, documents the astonishing range of street vendors, refuse collectors, delivery men, and salespeople walking around the

Image: Francis
Alÿs, *Turista*, 1996

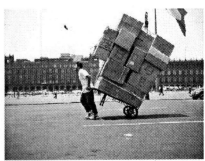

streets of Mexico City, pushing and pulling loaded carts or wheeled stalls, and occasionally carrying loads on their heads.

Works such as Potrč's and Alÿs' point to a widespread interest, among artists and curators, in the precarious existence of shanty town dwellers and of the millions of people across Third World cities whose mode of livelihood Mike Davis has described as 'informal survivalism.'[1] In order to address the apparent contradictions suggested by these works and by their appeal to official sponsors and institutions, I would like to sketch out some characteristic features of this trend and some of the problems it raises. Rather than providing a systematic overview, I will look in particular at the ways in which artists and curators have theorised this growing interest, and explore a few of the perils and promises that precariousness holds for contemporary art today.

On Adversity We Thrive!

Potrč was one of the artists included in the exhibition The Structure of Survival at the 50th Venice Biennale in 2003. The curator, the Argentinean Carlos Basualdo, chose to focus on the *favela* or shanty town as the guiding theme of the exhibition, which featured over 25 international artists. Basualdo's definition of the shanty towns as spaces of resistance, 'places in which original forms of socialisation, alternative economies, and various forms of aesthetic agency are produced' has been echoed in other fields.[2] The philosopher Slavoj Žižek, for example, believes that '[t]he new forms of social awareness that emerge from slum collectives will be the germs of the future and the best hope for a properly "free world."'[3] Basualdo's ideas on this question developed more specifically from his engagement with the work of Brazilian artist Hélio Oiticica, who coined the motto 'on adversity we thrive' ('da adversidade vivemos') in 1967.[4] Adversity, for Oiticica, was a condition of Third World countries, and should be the starting point for any Brazilian artist. Oiticica himself found inspiration for his work in the Brazilian popular culture of samba dancing and the shanty town

Images: Francis Alÿs, from the series *Ambulantes,* 1992–2002

Both Alÿs and Potrč have celebrated the ways people occupy space in an unplanned fashion and erect shelters spontaneously

architecture of the Rio *favela* of Mangueira.[5] In 2001, Basualdo appropriated Oiticica's motto as the title for an exhibition at the Musée d'Art Moderne de la Ville de Paris. Featured artists, among whom were included Francis Alÿs, as well as artists who would subsequently figure in the Venice Biennale show, were discussed in terms of their experience of a Latin American reality characterised by 'constant precariousness' and 'adversity in tragically unstable socio-economic contexts.'[6]

If the critic Guy Brett described precariousness as a characteristic of Latin American art as early as 1989,[7] Basualdo's shows have contributed to the growing celebration of contemporary practices relating to issues of adversity and crisis. In our current globalised world, as Basualdo has pointed out, crises operate beyond national boundaries, and beyond distinctions between developing and developed countries.[8] Yet rather than analyse the ways in which the First World societies may be in a state of crisis, Basualdo, like many artists, has focused on the ongoing inventiveness of those who experience adversity at first hand. The attraction of the precariousness of the Developing World for artists and curators seems to lie not in the situation of crisis itself as much as in the *responses* that it encourages. Potrč often speaks of the 'beauty' of slum architecture,[9] while Francis Alÿs marvels at the ways in which people in Mexico 'keep inventing themselves,' like a man in his neighbourhood who spends his day cleaning the gaps between the pavement flagstones with a bent wire.[10] The Turkish artist collective Oda Projesi, who were included in The Structure of Survival, seem to summarise a widespread, if often implicit, belief, when they explain that inhabitants of the prefabricated houses erected after the 1999 Adapazari earthquake 'construct these annexes by choosing the materials in accordance with their own conditions and needs, just like an artist or an architect.'[11] Similarly, both Alÿs and Potrč have celebrated the ways people occupy space in an unplanned fashion and erect shelters spontaneously. In 2003, Potrč exhibited a 'growing house' from a Caracas shanty town at the Palais de Tokyo in Paris. The 'iron wires sprouting from its rooftop,' according to

Image: Marjetica Potrč,
*Caracas: Growing
House*, 2003

her, 'proclaim the vitality of the place.'[12] In 1994, Alÿs pieced together electoral posters declaring 'housing for all' ('viviendas por todos') in order to create a shelter-like structure fastened over a subway air duct in Mexico City. 'It was a direct comment on the state of local politics and at the same time an attempt to recreate these cells of squatters that I encountered everywhere in the city,' he has explained.[13] Perhaps unsurprisingly, both Alÿs and Potrč come from an architectural background. Urban planning

is their frame of reference, and their concerns with precariousness mirror the emerging attraction among architects to the hitherto unmapped slums of Third World cities.

The abandonment and neglect experienced by, to use Mike Davis' term, the 'informal proletariat' seems to be conceived by artists such as Alÿs and Potrč as a kind of freedom. In a 1990 essay, Guy Brett explained that in Latin America 'many grass-roots movements have appeared because of a complete loss of

Alÿs has adopted compromise as the very modus operandi of his work

faith in the willingness or ability of governments to do anything about major problems.'[14] Many activists and non-governmental organisations in the West would recognise themselves in this description, and Latin American grass-roots movements have been models for similar groupings elsewhere. For Potrč, there is a direct parallel between NGOs and shanty towns: both have been '[g]rowing without any control or planning,' and both, according to the artist, embody our aspirations, dreams and ideals.[15]

In the catalogue for The Structure of Survival, Basualdo invited a group of Argentinean activists, Colectivo Situaciones, to write about responses to the devastating economic crisis in their country. Like many such groups, Colectivo Situaciones explain that their type of revolution differs from traditional 'modern emancipatory politics' in that they do not seek to gain state power. Instead, they are concerned with finding concrete means of self-sufficiently managing resources and of affirming common values of solidarity and sociability.[16] Similarly, Potrč believes that '[t]he world we live in today is all about self-reliance, individual initiative, and small-scale projects.'[17] This corresponds to a widespread belief that the utopias of the past, the grand narratives of 'emancipatory politics,' remain forever unattainable. Potrč focuses on 'small gestures, not big ones,'[18] while Alÿs, according to a critic, 'moves as an artist who has come to understand that the only thing left to do is to take small steps.'[19] Potrč does not wish to change anything, she claims she is interested in analysing, without judging, the 'facts of contemporary urban life.'[20] Alÿs, for his part, explains that Mexican society 'is a society that is governed by compromise' and that he has adopted compromise as the very modus operandi of his work.[21]

Neither Potrč nor Alÿs, however, perceive this resignation and compromise pessimistically. Like Colectivo Situaciones, they reject 'the idea that the omnipotence of market flows (with the wars that accompany them) leave no space for any struggles for

Life. Alÿs' *Ambulantes* seem to embody Certeau's idea that practitioners of everyday life constantly tinker 'within the dominant cultural economy in order to adapt it to their own interests and their own rules.'[23] On the one hand, Alÿs' photographs literally demonstrate practical tricks – such as how one can fit fourteen cardboard boxes onto one small hand-pulled cart. On the other hand, they point to the range of petty jobs that inhabitants of Third World countries have to keep inventing to survive and to find a useful function in a chaotic economy. As job precariousness has also become a concern for activist groups in First World countries – since 'jobs for life' are becoming a thing of the past – Alÿs' slide show immediately chimes with global struggles in the age of micropolitics.

Making Do

One of the problems with the discourse of precarity is the conflation of a wide variety of situations, ranging from the illegal immigrant working as a cleaner, or

liberation,' and believe that it is 'possible that power and its opposition can coexist long term without eliminating one another.'[22] In this sense, their outlook brings to mind Michel de Certeau's analysis of everyday life as containing in itself the potential means through which to subvert the dominant order from within. 'Making do' - 'faire avec' is, in fact, the title of a chapter in de Certeau's 1980 book entitled *The Practice of Everyday*

Image: Hélio Oiticica,
Parangolé

the employee in a call centre, to the freelance web designer or the projectionist at the Cannes film festival.[24] It is precisely this kind of confusion that can occur when precariousness is used as a privileged theme in contemporary art. Within this conflation, the emphasis on precariousness runs the risk of erasing crucial differences at the same time as it tries to bring together a disparate group in order to promote a specific argument. Basualdo's Da Adversidade Vivemos and The Structure of Survival certainly included a wide range of practices under the umbrella of crisis and adversity. Fernanda Gomes' installations, which were included in both exhibitions, display a vocabulary of simple, sometimes fragile, everyday objects, casually placed on the floor, hung or propped within an empty space. While these discrete and ephemeral arrangements evoke precariousness and instability, they seem far removed from the realities of everyday life in Latin American slums. Condemning Gomes' works for not having the same urgency as the works of some of her compatriots would be falling into the trap of asking them to conform to some kind of Latin American stereotype. Claiming that these works are about survival, or that they propose a model for a new type of ethical art would suggest, however, that precariousness *in itself* is subversive.

This problematic slippage can be better understood when reading statements by artists such as Potrč or Alÿs who speak of their work in terms of the 'human condition'. Potrč justifies her placement of shanty town architecture as 'case-studies' in galleries by explaining that galleries are 'places where we think the human condition',[25] whereas Alÿs claims he is 'trying to suggest this absolute acceptance of the "human condition"' by the people he sees struggling every day in his neighbourhood.[26] While the implications of Potrč's and Alÿs' works can indeed be extended from their locally

specific origin to encompass wider reflections on human finitude and inventiveness in the face of death, the logic that inflects Basualdo's readings of Gomes's work operates in reverse: installations that suggest a general sense of instability, transience or fragility, he seems to suggest, must *de facto* be related

Image: Hélio Oiticica,
*Parangolé, I am
Possessed*, 1964

The creation of a 'slum chic' style will no doubt find echoes in contemporary fashion and design trends

to the particularly precarious social and economic conditions of living in Latin America. I believe that this logic is erroneous, and that these distinctions remain crucial. There are substantial variations among artists working in different countries, and even within the same country distinctions should be highlighted among social and ethnic groups as well as successive generations of Latin American artists. Unlike Basualdo, I would like to emphasise the gap that separates Oiticica's 1960s oeuvre from some of the younger Brazilian artists, whose work betray the influence of the growing internationalisation of the art market. An instance of this shift can be seen in Alexandre da Cunha's work, which was included in The Structure of Survival. By displaying cheap objects (such as sleeping bags, raincoats and plastic brooms) to create shelter-like arrangements, da Cunha seems to me to be using conventional, trivial signifiers of precariousness in a way that aestheticises, rather than embodies or analyses the nature of this condition. The creation of a 'slum chic' style will no doubt find echoes in contemporary fashion and design trends. It is hard to find here even the slightest echoes of the existential precariousness hinted at by Gomes' ontological evocation of human finitude.

Where da Cunha seems to aestheticise the signifiers of precariousness, the Angolan artist Antonio Ole, also included in The Structure of Survival, seems to be aestheticising precariousness itself. By arranging found fragments of an impoverished architecture along the walls of the gallery in his *Township Wall*, Ole makes poverty look cheerful and picturesque. This points to a second major pitfall in the exploration of practices of 'making do' and thriving on adversity. This is a problem that Alÿs himself encountered when he was planning a film which sought to illustrate the virtue of 'valemadrismo,' the Mexicans' 'capacity to accommodate oneself

to *mala fortuna*, to bad luck, and even more, to actually turn one's misfortune into an advantage.'[27] This film was to tell the story of a dog called Negrito who lost a leg but went on to develop a very successful juggling trick using the bone of its broken leg. Although Alÿs has not given the reasons why he abandoned this film, he admits that it was a 'somewhat romanticised account,' and my guess is that he became wary of this. For celebrating *valemadrismo* can lead to an occlusion of the suffering itself, and perhaps even to a lapse back into a primitivising stereotype of the carefree, cheerful pauper who accepts his condition without protest. Calls such as David Aradeon's, reproduced in the catalogue for The Structure of Survival, to remember that inhabitants of Brazilian shanty towns are 'poor but vibrant, sensitive and creative,' can easily slip into a confirmation of such romanticising stereotypes.[28]

Such problems, I would like to argue, take us back to the crux of precariousness, and its existence at the junction of crises and reactions, of adversity and coping strategies. At the heart of this articulation lie two much broader issues. The first concerns the politics of the slums themselves. I mentioned earlier how Žižek has suggested that slum-dwellers constitute the new proletariat, the agents of the next revolutionary challenge to capital. However, not everyone shares his optimism. Davis, for example, argues that up until now the dominant political force in the slums has been organised religion;

survival rather than protest has remained - perhaps unsurprisingly - the main agenda of this 'informal proletariat.'[29] Thus the activity of 'making do' in itself could turn out to be more conservative than revolutionary, as millions of people struggle to make it through another day, with little possibility of making organised and effective demands. In this sense, Alÿs' interest in the Mexican's 'absolute acceptance' of their condition could be read as a call for passivity, rather than action. In order to contradict this narrative, and glimpse some potential change, it would be useful to further explore the grass-roots model of micropolitics, and the potential for change once the traditional revolutionary seizure of state power has been set aside in favour of 'self-reliance, individual initiative, and small-scale projects,' to use Potrč's terms. Colectivo Situaciones, after all, still believe in a 'struggle for liberation.' The question remains whether, and how, the model of effective reaction, which they have substituted for the Marxist call for action, can ultimately lead to such liberation.

The second issue raised by the politics of 'making do' is the question of agency. George Yúdice has criticised Michel de Certeau's notion of subversive tactics because they 'are wielded not only by workers but by the very same managers (and other elites) who reinforce the established order.'[30] In order to reveal the subversive potential of everyday life, it is necessary to '*distinguish* among the practitioners of such tactics in terms of

how the tactics enable them to survive and [to] challenge their oppressibility.'[31]

Towards a 'Coalition'?

In order to navigate these distinctions, I would like to finally turn to Žižek's definition of the slum-dwellers of the world as the 'counter-class to the other newly emerging class, the so-called "symbolic class" (managers, journalists and PR people, academics, artists etc.) which is also uprooted and perceives itself as universal.'[32] This definition, which effectively updates Marx's social analysis, seems to me to avoid the conflation of different kinds of precarious work in discourses about job security, while acknowledging a relationship that can be fruitful. Crucially, Žižek asks: 'Is this the new axis of class struggle, or is the "symbolic class" inherently split, so that one can make a wager on the coalition between the slum-dwellers and the "progressive" part of the symbolic class?'[33] My contention here is that some artists can indeed occupy the 'progressive' place of a symbolic class trying to forge a coalition in the arena of art and discourse. If the celebration of 'making do' tactics can be recuperated by a conservative discourse of passivity and conformism, it can also nevertheless contain the seeds of a globalised discourse of protest, as long as the agents of this coalition, and their respective needs for empowerment, are clearly distinguished. Once the utopias of the Left have been set aside, the objective for many artists today is to find ways of

bringing this coalition to light by eschewing the risks of voyeurism or romanticism. Potrč's rejection of 1980s social activism as reinforcing the marginalisation of the homeless and the poor is premised on a belief that artists need to move away from traditional models of critique in order to explore a model of the coalition based on *empathy*.[34] Alÿs adoption of compromise as a guiding force for the redefinition of artistic practice offers a similarly empathetic model through which to relate to the subjects with whom he co-exists in Mexico City. Other modes of coalition are being explored by contemporary artists, whether in traditional forms of documentary or activist reportage, or for example in the provocative alienation set up by Santiago Sierra's performances, which provocatively dramatise the radical differences between the informal proletariat and bourgeois art viewers.

Ultimately, the deep ambivalence that I experienced when I encountered Potrč's shelters in the white cube of the gallery points to the final, inevitable question for artists investigating precariousness: can the rarified conditions of display and reception in the contemporary art world really provide a platform for the exploration of political alternatives? Can art be a credible space in which to foreground this potentially revolutionary 'coalition between slum-dwellers and the "progressive" part of the symbolic class'? How artists manage to articulate this coalition within the framework of the

current artworld, and to what effect, constitutes one of the most interesting questions of contemporary art. It also happens to be one of the more urgent questions for society at large – especially if we agree with Potrč that when '[y]ou lose sight of your dreams, you die.'**35**

Image: Fernanda Gomes, *No title*, 2003, installed at The Structure of Survival

Footnotes

1
Mike Davis, 'Planet of Slums: Urban Involution and the Informal Proletariat', *New Left Review*, 26, March-April 2004, p. 24.

2
Carlos Basualdo, 'On the Expression of the Crisis', in Francesco Bonami (ed.), *Dreams and Conflicts: The Dictatorship of the Viewer*, exh. cat., Venice: Biennale, 2003, p. 243.

3
Slavoj Žižek, 'Knee-Deep', *London Review of Books*, vol. 26, no. 17, 2 September 2004, http://wwwlrb.co.uk/v26/n17/print/zize01_.html, accessed 17/05/2006, p. 5.

4
Oiticica used this motto in one of his works, a *Parangolé* cape, and included it in a manifesto-like text written on the occasion of the exhibition *Nova Objetividade Brasileira*, at the Museum of Modern Art in Rio de Janeiro.

5
I have written about Oiticica's relation to Brazilian popular culture in 'Tactile Dematerialisation, Sensory Politics: Hélio Oiticica's *Parangolés*', *Art Journal*, vol. 63, no. 2, Summer 2004, pp. 58-71.

6
Carlos Basualdo, 'A propos de l'adversité', in *Da Adversidade Vivemos*, exh. cat., Paris: Musée d'Art Moderne de la Ville de Paris, 2001, p. 13.

7
Guy Brett, 'A Radical Leap', in *Art in Latin America,*

The Modern Era, 1820-1980, exh. cat., London: Hayward Gallery, 1989, p. 255.

8
'On the Expression of the Crisis', pp. 243-244.

9
Marjetica Potrč, 'Urban, 2001', in *Marjetica Potrč: Next Stop, Kiosk*, Moderna Galerija Llubjana Museum of Art, 2003, p. 31.

10
'La Cour des Miracles: Francis Alÿs in conversation with Corinne Diserens', in *Francis Alÿs: Walking Distance from the Studio*, exh.cat., Wolfsburg: Kunstmuseum Wolfsburg, 2004, pp. 100-101.

11
Oda Projesi, 'Annex', on www.odaprojesi.com, accessed 20/03/2006.

12
Marjetica Potrč, 'In and out of Caracas', in *Marjetica Potrč*, p. 83.

13
'La Cour des Miracles', op. cit., p. 109.

14
Guy Brett, 'Border Crossings', in *Transcontinental: Nine Latin American Artists*, exh. cat., Birmingham: Ikon, 1990, p. 16.

15
Potrč, 'Urban, 2001', op. cit., p. 31.

16
Colectivo Situaciones, 'Through the Crisis and Beyond: Argentina', in Bonami (ed.), *Dreams and Conflicts*, p. 245.

17
Potrč, 'Back to Basics: Objects and Buildings', in *Marjetica Potrč*, p. 54.

18
Marjetica Potrč, 'Take me to Shantytown', *Flash Art*, March-April 2001, p. 98.

19
Annelie Lütgens, 'Francis Alÿs and the Art of Walking', in *Francis Alÿs: Walking Distance from the Studio*, p. 56.

20
'Tracking the Urban Animal', *Circa*, 97, Autumn 2001, p. 29.

21
'La Cour des Miracles', op. cit., p. 112.

22
Colectivo Situaciones, 'Through the Crisis and Beyond: Argentina', p. 245.

23
Michel de Certeau, *The Practice of Everyday Life*, transl. Steven F. Rendall, Berkeley and London: University of California Press, 1984, p. xiv.

24
For an overview of debates regarding job precarity, see 'Precarious Reader' *Mute*, vol II #0, London: 2005.

25
'Take me to Shantytown', p. 98.

26
'La Cour des Miracles', op. cit., p. 83.

27
Ibid., p. 85.

28
David Aradeon, 'Are We Reading Our Shanty Towns Correctly?' in Bonami (ed.), *Dreams and Conflicts*, p. 264.

29
'Planet of Slums', pp. 28-34.

30
George Yúdice, 'Marginality and the Ethics of Survival', *Social Text*, no. 21, 1989, p. 216.

31
Ibid., p. 217.

32
Žižek, op. cit., p. 5.

33
Ibid.

34
See 'Tracking the Urban Animal', op. cit., 29.

35
Potrč, 'Urban, 2001', op.cit., p.31.

Anna Dezeuze
<anna.dezeuze@manchester.ac.uk>
holds a Henry Moore Foundation
Postdoctoral Research Fellowship in Art
History and Visual Studies at the
University of Manchester. She is working
on a book project entitled 'The Almost
Nothing: Dematerialisation and the
Politics of Precariousness'

Images: Santiago
Sierra, *250 cm
Line Tattoed on 6
Paid People*, 1999

As London gentrifies its way toward the 2012 Olympics, social cleansing and riverine renewal proceed in parallel but more brutal form in Delhi. In preparation for the Commonwealth Games in 2010 the city's slum dwellers are being bulldozed out to make room for shopping malls and expensive real estate. Amita Baviskar reports on a tale of (more than) two cities and the slums they destroy to recreate

DEMOLISHING DELHI: WORLD CLASS CITY IN THE MAKING
by Amita Baviskar

Banuwal Nagar was a dense cluster of about 1,500 homes, a closely-built beehive of brick and cement dwellings on a small square of land in north-west Delhi, India. Its residents were mostly masons, bricklayers and carpenters, labourers who came to the area in the early 1980s to build apartment blocks for middle-class families and stayed on. Women found work cleaning and cooking in the more affluent homes around them. Over time, as residents invested their savings into improving their homes, Banuwal Nagar acquired the settled look of a poor yet thriving community – it had shops and businesses; people rented out the upper floors of their houses to tenants. There were taps, toilets, and a neighbourhood temple. On the street in the afternoon, music blared from a radio, mechanics taking a break from repairing cycle-rickshaws smoked *bidis* and drank hot sweet tea, and children walked home from school. Many of the residents were members of the Nirman Mazdoor Panchayat Sangam (NMPS), a union of construction labourers, unusual for India where construction workers are largely unorganised.

In April 2006, Banuwal Nagar was demolished. There had been occasions in the past when eviction had been imminent, but somehow the threat had always passed. Local politicians provided patronage and protection in exchange for votes. Municipal officials could be persuaded to look the other way. The NMPS union would negotiate with the local administration. Squatters could even approach the courts and secure a temporary stay against eviction. Not this time. Eight bulldozers were driven up to the colony. Trucks arrived to take people away. With urgent haste, the residents of Banuwal Nagar tore down their own homes, trying to salvage as much as they could before the bulldozers razed everything to the ground. Iron rods, bricks, doors and window frames were dismantled. TV sets and sofas, pressure cookers and ceiling fans, were all bundled up. The sound of hammers and chisels, clouds of dust, filled the air. There was no time for despair, no time for sorrow, only a desperate rush to escape whole, to get out before the bulldozers.

But where would people go? About two-thirds of home-owners could prove that they had been in Delhi before 1998. They were taken to Bawana, a desolate wasteland on the outskirts of the city designated as a resettlement site. In June's blazing heat, people

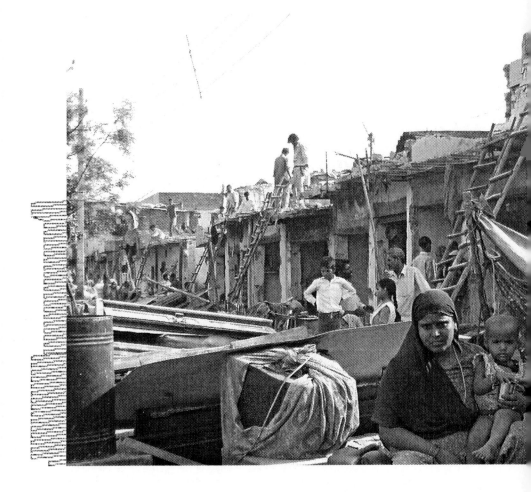

shelter beneath makeshift roofs, without electricity or water. Children wander about aimlessly. Worst, for their parents, is the absence of work. There is no employment to be had in Bawana. Their old jobs are a three-hour commute away, too costly for most people to afford. Without work, families eat into their savings as they wait to be allotted plots of 12.5 sq. m. Those who need money urgently sell their entitlement to property brokers, many of them moonlighting government officials.

Once, they might have squatted somewhere else in Delhi. Now, the crackdown on squatters makes that option impossible. They will probably leave the city.

One-third of home owners in Banuwal Nagar couldn't marshal the documentary evidence of eligibility. Their homes were demolished and they got nothing at all. Those who rented rooms in the neighbourhood were also left to fend for themselves. One can visit Bawana and meet the people who were resettled, but the

Image: Demolition of
Banuwal Nagar, 2006.
Amita Baviskar

rest simply melted away. No one seems to know where they went.
They left no trace. What was once Banuwal Nagar is now the site
of a shopping mall, with construction in full swing. Middle-class
people glance around approvingly as they drive past, just as they
watched from their rooftops as the modest homes of workers were
dismantled. The slum was a nuisance, they say. It was dirty,
congested and dangerous. Now we'll have clean roads and a nice
place to shop.

Banuwal Nagar, Yamuna Pushta, Vikaspuri – every day
another *jhuggi basti* (shanty settlement) in Delhi is demolished.
Banuwal Nagar residents had it relatively easy; their union was able
to intercede with the local administration and police and ensure
that evictions occurred without physical violence. In other places,
the police set fire to homes, beat up residents and prevented them
from taking away their belongings before the fire and the
bulldozers got to work. Young children have died in stampedes;
adults have committed suicide from the shock and shame of losing
everything they had. In 2000, more than three million people, a
quarter of Delhi's population, lived in 1160 *jhuggi bastis* scattered
across town. In the last five years, about half of these have been
demolished and the same fate awaits the rest. The majority of those
evicted have not been resettled. Even among those entitled to
resettlement, there are many who have got nothing. The
government says it has no more land to give. Yet demolitions
continue apace.

The question of land lies squarely at the centre of the demoli-
tion drive. For decades, much of Delhi's land was owned by the cen-
tral government which parcelled out chunks for planned develop-
ment. The plans were fundamentally flawed, with a total mismatch
between spatial allocations and projections of population and eco-
nomic growth. There was virtually no planned low-income housing,
forcing poor workers and migrant labourers to squat on public
lands. Ironic that it was Delhi's Master Plan that gave birth to its
evil twin: the city of slums. The policy of resettling these squatter
bastis into 'proper' colonies – proper only because they were legal
and not because they had improved living conditions, was fitfully
followed and, over the years, most *bastis* acquired the patina of de
facto legitimacy. Only during the Emergency (1975-77) when civil
rights were suppressed by Indira Gandhi's government, was there a

Ironic that it was Delhi's Master Plan that gave birth to its evil twin: the city of slums

concerted attempt to clear the *bastis*. The democratic backlash to the Emergency's repressive regime meant that evictions were not politically feasible for the next two decades. However, while squatters were not forcibly evicted, they were not given secure tenure either. Ubiquitous yet illegal, the ambiguity of squatters' status gave rise to a flourishing economy of votes, rents and bribes that exploited and maintained their vulnerability.

In 1990, economic liberalisation hit India. Centrally planned land management was replaced by the neoliberal mantra of public-private partnership. In the case of Delhi, this translated into the government selling land acquired for 'public purpose' to private developers. With huge profits to be made from commercial development, the real estate market is booming. The land that squatters occupy now commands a premium. These are the new enclosures: what were once unclaimed spaces, vacant plots of land along railway tracks and by the Yamuna river that were settled and

made habitable by squatters, are now ripe for redevelopment. Liminal lands that the urban poor could live on have now been incorporated into the profit economy.

The Yamuna riverfront was the locale for some of the most vicious evictions in 2004 and again in 2006. Tens of thousands of families were forcibly removed, the bulldozers advancing at midday when most people were at work, leaving infants and young children at home. The cleared river embankment is now to be the object of London Thames-style makeover, with parks and promenades, shopping malls and sports stadiums, concert halls and corporate offices. The project finds favour with Delhi's upper classes who dream of living in a 'world-class' city modelled after Singapore and Shanghai. The river is filthy. As it flows through Delhi, all the freshwater is taken out for drinking and replaced with untreated sewage and industrial effluent. Efforts to clean up the Yamuna have mainly taken the form of removing the poor who live along its banks. The river remains filthy, a sluggish stream of sewage for most of the year. It is an unlikely site for world-class aspirations, yet this is where the facilities for the next Commonwealth Games in 2010 are being built.

For the visionaries of the world-class city, the Commonwealth Games are just the beginning. The Asian Games and even the Olympics may follow if Delhi is redeveloped as a tourist destination, a magnet for international conventions and sports events. However wildly optimistic these ambitions and shaky their foundations, they fit perfectly with the self-image of India's newly-

confident consuming classes. The chief beneficiaries of economic liberalisation, bourgeois citizens want a city that matches their aspirations for gracious living. The good life is embodied in Singapore-style round-the-clock shopping and eating, in a climate-controlled and police-surveilled environment. This city-in-the-making has no place for the poor, regarded as the prime source of urban pollution and crime. Behind this economy of appearances lie mega-transfers of land and capital *and* labour; workers who make the city possible are banished out of sight. New apartheid-style segregation is fast becoming the norm.

The apartheid analogy is no exaggeration. Spatial segregation is produced as much by policies that treat the poor as second-class citizens, as by the newly-instituted market in real estate which has driven housing out of their reach. The Supreme Court of India has taken the lead in the process of selective disenfranchisement. Judges have remarked that the poor have no right to housing: resettling a squatter is like rewarding a pickpocket. By ignoring the absence of low-income housing, the judiciary has criminalised the very presence of the poor in the city. Evictions are justified as being in the public interest, as if the public does not include the poor and as if issues of shelter and livelihood are not public concerns. The courts have not only brushed aside representations from *basti*-dwellers, they have also penalised government officials for failing to demolish fast enough. In early 2006, the courts widened the scope of judicial activism to target illegal commercial construction and violations of

building codes in affluent residential neighbourhoods too. But such was the outcry from all political parties that the government quickly passed a law to neutralise these court orders. However, the homes of the poor continue to be demolished while the government shrugs helplessly.

Despite their numbers, Delhi's poor don't make a dent in the city's politics. The absence of a collective identity or voice is in part the outcome of state strategies of regulating the poor. Having a cut-off date that determines who is eligible for resettlement is a highly effective technique for dividing the poor. Those who stand to gain a plot of land are loath to jeopardise their chances by resisting eviction. Tiny and distant though it is, this plot offers a secure foothold in the city. Those eligible for resettlement part ways from their neighbours and fellow-residents, cleaving communities into two. Many squatters in Delhi are also disenfranchised by ethnic and religious discrimination. Migrants from the eastern states of Bihar and Bengal, Muslims in particular, are told to go back to where they came from. Racial profiling as part of the war on terror has also become popular in Delhi. In the last decade, the spectre of Muslim terrorist infiltrators from Bangladesh has become a potent weapon to harass Bengali-speaking Muslim migrants in the city. Above all, sedentarist metaphysics are at work, such that all poor migrants are seen as forever people out of place: Delhi is being overrun by 'these people'; why don't they go back to where they belong? Apocalyptic visions of urban anarchy and collapse are ranged alongside dreams of gleaming towers, clean

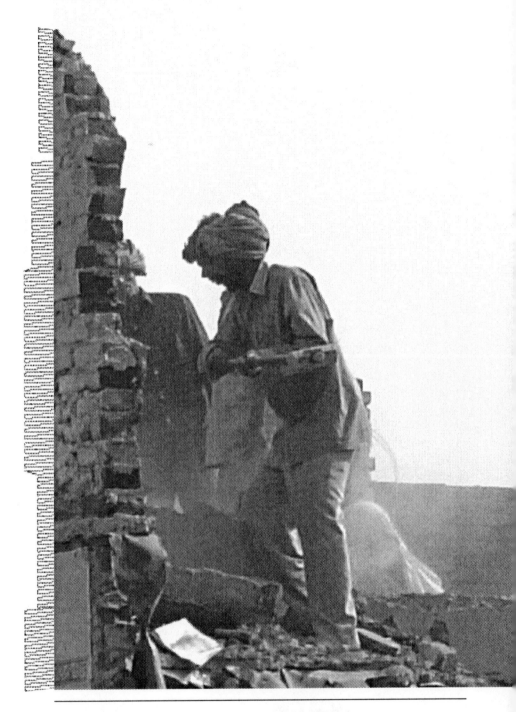

Image: Demolition of
Banuwal Nagar, 2006.
Amita Baviskar

streets and fast-moving cars. Utopia and dystopia merge to propose a future where the poor have no place in the city.

Delhi, Mumbai, Kolkata and many other Indian cities figure prominently in what Mike Davis describes as a 'planet of slums'. Slum clearances may give India's capital the appearance of a 'clean and green Delhi' but environmental activism has simply shifted the problem elsewhere. The poor live under worse conditions, denied work and shelter, struggling against greater insecurity and uncertainty. Is Davis right? Has the late-capitalist triage of humanity already taken place? Even as demolitions go on around me, I believe that Davis might be wrong in this case. Bourgeois Delhi's dreams of urban cleansing are fragile; ultimately they will collapse under the weight of their hubris. The city still needs the poor;

it needs their labour, enterprise and ingenuity. The vegetable vendor and the rickshaw puller, the cook and the carpenter cannot be banished forever. If the urban centre is deprived of their presence, the centre itself will have to shift. The outskirts of Delhi, and the National Capital Region of which it is part, continue to witness phenomenal growth in the service economy and in sectors like construction. Older resettlement colonies already house thriving home-based industry. The city has grown to encompass these outlying areas so that they are no longer on the spatial or social periphery. This longer-term prospect offers little comfort to those who sleep hungry tonight because they couldn't find work. Yet, in their minds, the promise of cities as places to find freedom and prosperity persists. In those dreams lies hope. ⟶

Amita Baviskar <baviskar1@vsnl.com> researches the cultural politics of environment and development. She is the author of *In the Belly of the River: Tribal Conflicts over Development in the Narmada Valley* and has edited *Waterlines: The Penguin Book of River Writings.* She is currently writing about bourgeois environmentalism and spatial restructuring in the context of economic liberalisation in Delhi

Far from being 'safe as houses', real estate can be a problematic means of capital accumulation. Here Rachel Weber gives an historical account of how the state has intervened to transform real estate into a more attractive and profitable commodity, from the top down 'creative destruction' of the welfare state, to the abandonment of potentially profitable areas to the forces of privatisation by the neoliberal 'contract state'

EXTRACTING VALUE FROM THE CITY: NEOLIBERALISM AND URBAN REDEVELOPMENT by Rachel Weber

The promise of durability has attracted kaisers, kings, mayors, and other megalomaniacs to the built environment. The physical-technical ensemble of the city – buildings, sewers, roads, monuments, transport networks – conveys a sense of fixity and obduracy that appeals to the political desire to make strong, lasting statements. However, these same characteristics often throw up challenges for the private capital that undergirds and enables urban development policies. The accumulation process experiences uncomfortable friction when capital (i.e. 'value in motion') is trapped in steel beams and concrete. The very materiality of the built environment sets off struggles between use and exchange values, between those with emotional attachments to place and those without such attachments.

In order to reconcile the political imperative to build with the capitalist demand for liquidity, states have developed mechanisms to make the built environment more flexible and responsive to the investment criteria of real-estate capital. At the national scale in Europe and North America, these efforts include everything from funding for post-war urban renewal to neoliberal policy moves such as deregulating financial markets, commodifying debt (e.g. through mortgage securitisation), destroying certain credit shelters for housing, and providing increasing support for real-estate syndications. Local states have produced their own set of directives, most aimed at absorbing the risks and costs of land development so capitalists do not have to do so. Municipalities justify such interventions by strategically stigmatising those properties that are targeted for demolition and redevelopment. These justifications draw strength from the dual authorities of law and science in order to stabilise inherently ambiguous concepts like blight and obsolescence and create the appearance of certitude out of the cacophony of claims about value. This research examines the changing role of states in property devaluation in the United States, searching in the detritus of the built environment for clues about regime shifts.

Value in the Built Environment

Capital circulates through the built environment in a dynamic and erratic fashion. At various points in its circulation, the built environment is junked, abandoned, destroyed, and selectively reconstructed. The physical shells of ageing industrial orders may sit dormant for decades before being cleared for a new high-tech 'campus', while bedsits near the central business district come down efficiently to be reborn as luxury condominiums within a year. Marx saw the tendency of solid material to decompose and melt as a basic fact of modern life (Berman 1988). Contemporary scholars have gone a step further, analysing the progression of time-space-structured transformations that revalorise devalued landscapes (Bryson 1997; Harvey 1989a; Smith 1996; Zukin 1982).

As a spatially embedded commodity, real estate embodies a crucial paradox. Real

estate has always attracted a range of investors, from the small-scale speculator-next-door to the largest insurance companies, because the investment produces an alienable commodity whose association with a particular location makes it scarce and valuable (Fainstein 1994). Fee-simple ownership accords the owners the legal right to capture any socially produced increases in ground rent plus the value of the improvements. If returns from rents and future sales are sufficient to pay off the initial development costs and also meet the fees and time horizons of creditors and investors, new cycles of investment can be set in motion.

On the other hand, the fact that capital invested in the built environment is immobilised for long periods of time detracts from real estate's attractiveness as an investment instrument. Real estate is illiquid, entails high transaction costs upon sale, requires security, and is not easily divisible. Longer turnover periods create barriers to further accumulation, as capital gets tied up in situ until it returns a profit. The obduracy of real estate resists frequent modification (Hommels 2000). These qualities make the commodity of real estate especially sensitive to devalorisation, especially in contrast to machinery and other forms of fixed capital (Harvey 1982).

Schumpeter's notion of 'creative destruction' captures the way in which capital's restless search for profits requires constant renewal through galelike forces that simultaneously make way for the new and devalue the old.

What is left behind by innovation is considered 'obsolete'. Obsolescence implies something out of date – a product, place, or concept displaced by modernisation and progress. Appraisers divide property conditions into functional and economic obsolescence, categories that correspond roughly to value changes in location and improvements.

States and Creative Destruction

It would be a mistake to view the creative destruction of the built environment as purely market-determined, a disembodied and overdetermined process that progresses in a linear fashion and is catalysed by every withdrawal and subsequent injection of capital. The price mechanism alone does not determine if and when buildings will be devalued, demolished, or reborn. The private real-estate market often cannot supply all the conditions necessary for

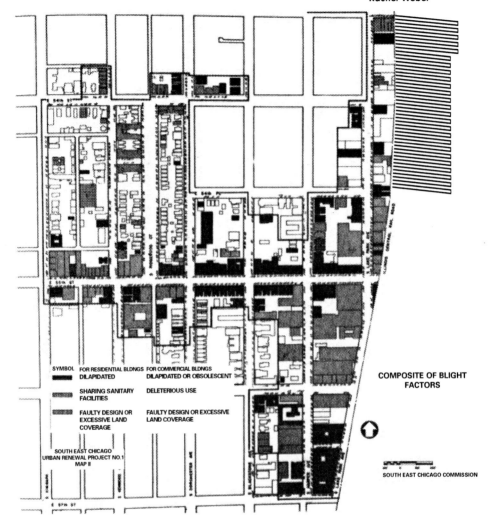

SYMBOL FOR RESIDENTIAL BLDNGS FOR COMMERCIAL BLDNGS
 DILAPIDATED DILAPIDATED OR OBSOLESCENT

 SHARING SANITARY DELETERIOUS USE
 FACILITIES

 FAULTY DESIGN OR FAULTY DESIGN OR EXCESSIVE
 EXCESSIVE LAND LAND COVERAGE
 COVERAGE

SOUTH EAST CHICAGO
URBAN RENEWAL PROJECT NO.1
MAP II

COMPOSITE OF BLIGHT
FACTORS

SOUTH EAST CHICAGO COMMISSION

the extraction of value (Feagin 1998). Within each locale, a lattice of state and non-state institutions – thick and hierarchal in some places, thin and ephemeral in others – influence value in the built environment.

Interventions into real-estate markets require states to juggle two contradictory imperatives: 'to maintain or create the conditions in which profitable capital accumulation is possible', while at the same time managing the potential political repercussions (O'Connor 1973:6). Balancing accumulation and legitimation is a difficult task: the extension of the state into the market renders the political, economic, and legal bases of corporate legitimacy visible and thus vulnerable to interrogation and resistance (Habermas 1973). State actors may 'mystify (their) policies by calling them something they are

Image: Composite of Blight
Factors, Map no. 11, from
South East Chicago
Renewal Project No. 1
(Chicago: South East
Chicago Commission, 1954)

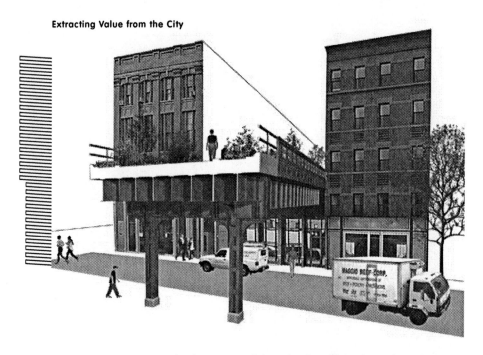

not,' or 'try to conceal them (e.g. by making them administrative, not political, issues)' (O'Connor 1973:6).

Beyond obfuscation and redistribution, states may neutralise some of the conflict surrounding value in the built environment by bringing different kinds of expertise to bear on divisive issues in the hopes of achieving some semblance of ideological 'closure'. States have historically relied on the collaborating authorities of law and science to legitimise different regulatory regimes. Both law and science share a general commitment to resolving conflict through the discovery of truths. Laws convert state power into deeply embedded routines, the legitimacy of which depends on the perceived rationality of established procedures, the appearance of neutral administration, and the de facto acceptance of an order of authority by its subjects (Weber 1978). Science promises a similar mastery over the irrational, contested, and ambiguous. To the extent that the knowledge justifying state policies can be construed as natural, scientific 'truths' perform the task of reproducing the values and credibility of state institutions (Callon, Law, and Rip 1986; Wynne 1989).

Finding value or a lack thereof in the built environment is an arbitrary and inconsistent process in which the state, particularly the local state, offers its assistance. States discursively constitute, code, and order the meaning of place through policies and practices that are often advantageous to capital (Beauregard 1993). Because the

Image: Architect's pro-
jection for redevelp-
ment of the High Line,
a disused elevated rail-
way in New York

presence or absence of value is far from straightforward, states attempt to create a convergence of thinking around such critical issues as the economic life of buildings, the priority given to different components of value, the sources of devaluation, and interrelationships between buildings and neighbourhoods

Urban Blight and Renewal

In the post-war period credit availability, relatively high wages, and national subsidies – particularly to the growing ranks of the white middle classes in the form of

insurance (for bank deposits and mortgages) and defense contracts – helped fuel a postwar building expansion in the suburbs. Depopulated of their middle- and upper-income residents, cities became home to concentrations of poor immigrants and African-American migrants who lived and worked in an aging built environment. In the middle of the century, the federal government possessed the tax revenue and the political will necessary for robust, national-level interventions (Teaford 1990). Starting with the Housing Act of 1949 and the amending Housing Act of 1954, cities received a growing stream of federal aid to purchase inner-city property for urban

Image: High Line, 2006

redevelopment and renewal. To receive the federal funds for land acquisition, they were required to draw up plans for development, form renewal agencies emboldened with new legal powers, and create mechanisms to quickly appropriate devalued property

space is more malleable and potentially more valuable to investors when it is empty

(von Hoffman 2000). Massive amounts of federal funds flowed into US cities through the 1970s, subsidising developers and unionised construction workers with cleared prime land at bargain-basement prices (i.e. 'write-downs').

To dispose of devalued properties during this era and prepare space for new rounds of investment, the national state collaborated with the local state to create quasi-scientific methods for identifying 'blight'. The language of urban destruction evolved from the vice-obsessed teens and '20s into its own technical language in roughly the middle third of the century. Historic accounts of urban policy during this period point to blight as the primary justification for creative destruction

(Beauregard 1993; Fogleson 2001; Page 1999). In the local renewal ordinances and state statutes of this period, the definition of blight is vague: it is framed as both a cause of physical deterioration and a state of being in which the built environment is deteriorated or physically impaired beyond normal use. The discourse of blight appropriated metaphors from plant pathology (blight is a disease that causes vegetation to discolor, wilt, and eventually die) and medicine (blighted areas were often referred to as 'cancers' or 'ulcers'). The scientific basis for blight drew attention to the physical bodies inhabiting the city, as well as the unhygienic sanitary conditions those bodies 'created'.

Armed with checklists of the spatial-temporal qualities that constituted blight (i.e. 'blighting factors'), some of which had been developed in the 1950s by the American Public Health Association, planners' standardised techniques hid underlying motives and biases. The checklists included factors like the age of buildings (their 'useful life', in most cases, was considered to be 40 to 50 years), density, population gain or loss, overbuilding on lots, lack of ventilation and light, and structural deterioration. The criteria for blight designation sometimes referred to public health statistics such as the death rates from tuberculosis and syphilis (see, for example, *Morris v. District of Columbia Redevelopment Land Agency* 117 F. Supp. 705, 1953). Many of the blight indicators involved some sort of mixing or blurring of boundaries: a mixture of land uses or of the race and ethnicity of residents. As Swartzbaugh

(2001) notes in her historical study of race in Chicago, even though buildings on the black South Side were not as old as those on the north and west sides of that city, they were more frequently categorized as unfit or substandard.

The early redevelopment legislation and city ordinances are notable for three areas of emphasis: first, the compromised use-values of residents living in blighted neighbourhoods and buildings; second, a focus on building new low-income housing to replace the deteriorated stock; and third, justifications for managerial state intervention in order to eliminate or prevent conditions injurious to the public health, safety, morals, or welfare. In the legal challenges that have followed, blight was perceived as a legitimate precondition for demolition and new housing construction because it produced hardships for residents and bred crime and disease (Quinones 1994). Obsolescence, on the other hand, primarily limited the profitability of property owners and was a more questionable justification for the use of urban police powers (i.e. 'public purpose'). In the context of American-style welfare capitalism, targeting blight instead of obsolescence allowed the state to destroy with a public purpose – the laudable goal of 'healthy' cities – as the moral overtones of blight blurred the boundaries between public and private responsibility.

Urban renewal pulverised the inner city in the middle of the century, funneling billions of federal dollars into costly downtown commercial projects, highways, and sanitised streetscapes. Between 1949 and 1965, one million people, mostly low-income, were evicted in the name of eliminating and containing blight (Hall 1996). Ultimately, rent strikes, widespread protests, Black Power, Jane Jacobs, and several crucial lawsuits helped to replace renewal funds with community development block grants and diffuse the power of the renewal agencies to a broader network of neighbourhoods and state actors. Renewal opposition was successful partly because organisations and lawsuits challenged the scientific and legal basis of blight, unhinging the signifier from the referent. Friedman (1968:159) observed, 'Finding blight merely means defining a neighbourhood that cannot effectively fight back, but which is either an eyesore or is well-located for some particular construction project that important interests wish to build.' Blight was maligned as a convenient incantation to justify the use of redevelopment powers for projects that were already planned. However, although resistance to the demolition and redevelopment plans was organised and powerful enough to slow the federal bulldozer, efforts to undermine the legitimacy of 'blight' did not entirely remove the term or its legacy from the lexicon of urban policymaking.

The Neoliberalisation of Devalued Property

The 1970s brought high inflation, an increasingly global context for investment, and a flood of capital from basic manufacturing into real estate and other

speculative investments. The same phenomena that hastened the demise of Fordism also lowered the risk-adjusted returns on capital invested in the built environment vis-à-vis other asset categories. On the demand side, capitalists found that accumulation was better served by keeping financial resources churning rapidly within the system, rather than making sunk costs that would expose capital to great risks (Dow 1999).

Since the 1970s, capital deployment and turnover times have sped up, as have flows of information and signs in general (Lash and Urry 1987; Virilio 1986). On the supply side, in order to attract capital looking for large, liquid trading markets,

the commodity of real estate has become progressively dematerialised and deterritorialised. Real estate has lost its status as a distinct and quirky asset class, in the process becoming more detached from place and more subject to the disciplining power and accelerated schedules of global capital markets.

The federal government actively accommodated the drive for liquidity in real estate by creating new forms of property and incentives to invest in real estate through tax policies, such as shelters, deductions, and tax credits. By creating a secondary mortgage market through quasi-public institutions (e.g. Fannie Mae, the Federal National Mortgage Association, formed in 1938), the

Images: New York's
'Alphabet City' in the
1970s

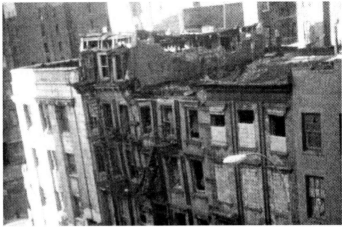

state has increased the total size of capital flows with the unattainable aim of reducing cyclical instability of real-estate capital. These institutions buy mortgages, package them, and guarantee their payments with government backing on mortgage-backed securities held by other institutions, such as pension funds. Securitisation connects real-estate credit markets to the nation's general capital markets and creates more liquidity in the system (Budd 1999). The secondary mortgage market also enables investors in one part of the country to invest in mortgages originated in another region, effectively ending the geographic segmentation of credit (Schill 1999). These innovations, mediated by the development of new electronic trading technologies, have increased the pace of financial transactions so that capital does not get grounded for too long.

The federal government also deregulated the thrifts (i.e. saving and loan associations) in the 1970s and lifted the ceilings on interest rates. Less regulated institutional investors (e.g. mutual and pension funds) and insurance companies became engaged in bank-like activity displacing banks from the credit markets they formerly dominated. Enacting a change in tax shelters in 1981, the Reagan administration effectively bolstered the role of equity syndicators, such as tax exempt real-estate investment trusts for corporates (REITs) which create a similar structure for real estate investment to that of mutual funds for stocks, flooding the markets with capital. The resulting overaccumulation resulted in the over-building of the 1980s (Fainstein 1994), particularly in the Sunbelt office sector, and led the real-estate industry into its worse crisis since the Great Depression.

Financial deregulation and the increasing securitisation of real estate removes owners from actual structures and moves locally

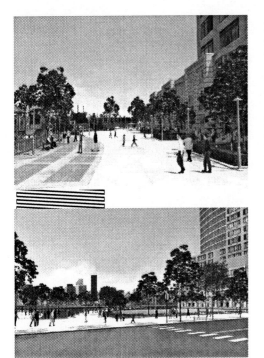

lack in-depth knowledge of and familiarity with the markets in which they operate. For this reason, the spatial distancing of real-estate investments may encourage the demolition of devalued properties over their rehabilitation. Although each location in space is unique and requires place-specific knowledge (e.g. of the demand for local real estate, zoning regulations) to assess its value, land that is devoid of improvements is more recognisable to the abstracting, utilitarian logic of capital markets. Rehabilitation and upgrading requires additional knowledge (of contractors and building materials) that distant investors often lack. In comparison, space is more malleable and potentially more valuable to investors when it is empty. If higher degrees of local knowledge are required, either profits will have to be higher in order to compensate for these inflexibilities (Clark and O'Connor 1997) or other parties, such as the state, will have to assume a portion of these additional costs.

determined value away from the underlying property. Determining a property's true value requires detailed knowledge of the local real-estate market (Warf 1999). Distant capitalists will only invest if the property is recognisable beyond its unique character embedded in space and if it can provide short-term returns. When these conditions are met, the particularity of a building is transformed into the uniformity of a financial 'instrument' and place becomes subordinated to 'a higher realm of ordering beyond territorialism: speed' (Douglas 1999:146).

If these conditions are not met, disinvestment may occur. Distant investors that operate in many jurisdictions often

The globalisation of real-estate capital and the dematerialisation of property have created new challenges for the local state. Municipalities are subject to a highly territorialised fiscal dependency, and they operate in a more delimited and competitive space than do national regimes. Moreover their ability to raise the revenues with which to bid blindly for private investment is controlled by higher orders of government, such as state-government-imposed debt caps. Rather than retreat from policymaking, the last two decades have witnessed a proliferation of municipal regimes

Images: Approved plans for the recently rezoned industrial-come-boho quarter of Williamsburg, Brooklyn

increasingly active in creating landscapes amenable to the quick excavation of value (Swyngedouw 1997). Cutting back national sources of assistance, such as urban renewal dollars and development block grants, has only aggravated interjurisdictional competition, raising the stakes and encouraging more desperate efforts to pin down increasingly fleet-footed capital.

Whereas the national and local bureaucracies of the Keynesian state formed a thick structure of organised power around urban renewal, local strategies now emanate from a hollowed-out, 'contract' state (Jessop 1998; Strange 1996). Local government functions have been sold to the lowest-cost bidders: to private consulting firms (who draft neighborhood plans), bond underwriters (who help municipalities privatise infrastructure development and management and then underwrite the bonds to pay for those activities), and non-profits (who build and manage housing and social services for those displaced from public housing). Whereas cities were beholden to the temporal pressures of the federal government during urban renewal, they are now dependent on the short-term horizons of REITs and those institutional investors who purchase municipal bonds. The contract state operates through decentralised partnerships with real-estate capitalists, and what remains of the local state structure has been refashioned to resemble the private sector, with an emphasis on customer service, speed, and entrepreneurialism. The narrative of entrepreneurialism (defined broadly as a combination of competitive, growth-oriented local economic development strategies, intimate public-private collaborations, and boosterism (Harvey 1989b; Jessop 1998)), has underpinned city management practices since the late 1980s, as local governments attempt to project modern self-images and embrace innovative tactics to remake old spaces in the face of global competition (see MacLeod in Brenner and Theodor 2002).

The marketised ideologies of neoliberalism as articulated in the entrepreneurial practices of cities stress different justifications for the stigmatisation of space necessary for its revalorisation. Agricultural and medical metaphors may have been appropriate for the rapidly urbanising society of the mid-20th century, with its rural roots and relative bureaucratic legitimacy. However, the civil rights movement, dissolution of Keynesian managerialism, and numerous legal challenges forced cities to be more cautious about recalling the paternalism of the welfare state. Cities have attempted to sidestep this ideological minefield in two related ways. First, they have further distanced themselves from those 'long-turnover' parts of the city where redevelopment needs are great but where the probability of private investment and extracting additional value is low. Second, although cities continue to identify blight in order to stigmatise space, I would argue that some of the concept's welfarist associations have been neutralised by the overarching narrative of municipal entrepreneurialism and its antithesis, the narrative of obsolescence. Obsolescence has

Neoliberal redevelopment policies amount to little more than property speculation and public giveaways

become a neoliberal alibi for creative destruction, and therefore an important component in contemporary processes of spatialised capital accumulation.

There is nothing new about obsolescence. Concerns that the city as a settlement form was obsolete were voiced in earlier parts of the century (Beauregard 1993), and obsolescence is frequently cited as one of many 'blighting factors' in redevelopment from the 1930s onward. Obsolescence poses a greater threat to exchange values than to use values, whereas blight threatens both. An obsolete building, one that has overly high ceilings, is not physically unusable but rather cannot be used as profitably as one with lower ceilings and modern heating systems.

Proof of obsolescence, therefore, requires the demonstration of an objective loss of exchange value, rather than a subjective comment on the loss of utility for a building's current residents. Appraisers, developers, and local officials point to certain indicators, such as rental values that are less than either the cost of demolition or accumulated depreciation (Urban Land

Institute, 1996). Obsolete office buildings can then be reclaimed as lofts, obsolete zoning and building codes can be revamped so that they are more user-friendly, and obsolete manufacturing space can be demolished to increase the supply of potentially developable land. Or, as one excited journalist noted about New York City, 'after languishing on the sidelines as the wallflowers of the real-estate industry, outmoded industrial buildings, vacant for years, are being pursued by investors and developers who are profiting by dressing them up and dancing them around again' (Charles 1998: 1).

Couching justifications for redevelopment in the language of obsolescence allows entrepreneurial cities to evade responsibility for the less commodified components of welfare, such as health, safety, and morals, previously assumed (at least discursively) by the early managerialist state. On the surface, obsolescence appears morally and racially neutral, as if the social has been removed from an entirely technical matter. Whereas the Keynesian state framed slum

clearance as a government responsibility to aid victim-residents, entrepreneurial urban policies use discursive frames that assign neither blame nor responsibility. What is responsible for obsolescence? Time, for one. Buildings age in what is framed as a natural, inevitable, and irreversible process. They are replaced by successively more modern structures. Functional obsolescence is simply the spatialisation of turnover time; it is time given material expression in physical space. Obsolescence takes the agency from the owner-investor-tenant and relocates it in the commodity itself.

Markets are also responsible for obsolescence, although, by virtue of their lack of agency, they are cleared of any moral charge for the outcome of uneven development. Innovation and changing consumer demand, the logic goes, will create excess capacity in any market as new commodities become desirable and older ones fall out of favour (e.g. suburban greenfield versus urban brownfield sites). Markets are the straightforward expression of the popular will, and 'since markets are the product of our choices, we have essentially authorised whatever the market does to us' (Frank 2001:5). As the correlate of gentrification, obsolescence appeals to the individualist notions of taste and preference that guide consumption and trump any structural or social explanations for wide-scale devaluation (Smith 1996). The market is viewed as an omniscient and neutral arbiter of value, with consumer sovereignty as the link between freedom and capitalism.

Conclusion

As the federal-grants economy that funded urban renewal efforts has been dismantled, entrepreneurial cities have sought to distance themselves from prior welfarist commitments, reclaim obsolete spaces, and find innovative ways to make costly redevelopment projects 'pay for themselves'. Devolution increased cities' dependence on own-source revenues, namely property tax revenues, which in turn made them more dependent on those that create value: the private real-estate market. Neoliberal redevelopment policies amount to little more than property speculation and public giveaways to guide the place and pace of the speculative activity

The local state's dependence on its own property base and its willingness to subject that base to market rule accounts for the renewed zeal with which it stigmatises space. Obsolete buildings melt into air, making it easier for the state to match distant investors with the empty, deterritorialised spaces left behind. However, reliance on the erratic capital markets to reinvigorate devalued properties often jeopardises the fiscal health of cities. Such speculative risks expose the fact that control is costly in neoliberal regimes where value in the built environment depends on the circulation of fast, fictitious money and an unruly web of politicised and marketised relationships. ⌐╮

Credit
The full length version of this text was first published as 'Extracting Value from the City: Neoliberalism and Urban Redevelopment', *Antipode* 34:3, Summer 2002, and in Neil Brenner and Nik Theodore, eds, *Spaces of Neoliberalism: Urban Restructuring in North America*, Blackwell, 2002

References

R. Beauregard, *Voices of Decline,* Cambridge, MA: Blackwell, 1993.

M. Berman, *All That Is Solid Melts into Air,* New York: Penguin Books, 1988.

J. Bryson, 'Obsolescence and the Process of Creative Reconstruction', *Urban Studies* 34(9):1439–1458, 1997.

L. Budd, 'Globalization and the Crisis of Territorial Embeddedness in International Financial Markets', in R Martin ed., *Money and the Space Economy* (pp. 115-138), London: Wiley, 1999.

M. Callon, J. Law and A. Rip, (eds), *Mapping the Dynamics of Science and Technology: Sociology of Science in the Real World,* Basingstoke: Macmillan, 1986.

E. Charles, 'With Space Tight, Outdated Factories Find New Roles', *The New York Times* (Section 11), January 4: 1, 1998.

G. Clark and K. O'Connor, 'The Informational Content of Financial Products and the Spatial Structure of the Global Finance Industry', in K. Cox, ed., *Spaces of Globalization: Reasserting the Power of the Local* (pp. 89–114). New York: Guilford, 1997.

I. Douglas, 'Globalization of Governance: Toward an Archeology of Contemporary Political Reason', in A. Prakash and J. Hart, eds, *Globalization and Governance,* (pp. 134–160), New York: Routledge, 1999.

S. Dow, 'The Stages of Banking Development and the Spatial Evolution of Financial Systems', in R. Martin, ed., *Money and the Space Economy* (pp. 31–48). London: Wiley, 1999.

S. Fainstein, *The City Builders: Property, Politics, and Planning in London and New York.* Cambridge, MA: Blackwell, 1994.

J. Feagin, *The New Urban Paradigm,* Lanham, MD: Rowman and Littlefield Fogleson R. (2001), *Downtown: Its Rise and Fall, 1880–1950,* New Haven, CT: Yale University Press, 1998.

T. Frank, The God That Sucked, *The Baffler,* Spring 14, pp. 1-9.

L. Friedman, *Government and Slum Housing: A Century of Frustration,* Chicago: Rand McNally, 1968.

J. Habermas, *Legitimation Crisis,* Boston: Beacon Press, 1973.

P. Hall, *Cities of Tomorrow,* Oxford: Blackwell, 1996.

D. Harvey, *The Urban Experience,* Baltimore: Johns Hopkins Press, 1989a.

D. Harvey, 'From Managerialism to Entrepreneurialism: The Transformation of Urban Governance in Late Capitalism', *Geographiska Annaler* 71B:3–17, 1989b.

D. Harvey, *The Limits to Capital,* Oxford: Basil Blackwell, 1982.

A. Hommels, 'Obduracy and Urban Sociotechnical Change': Changing Plan, 2000.

B. Jessop, 'The Narrative of Enterprise and the Enterprise of Narrative: Place Marketing and the Entrepreneurial City', in T. Hall and P. Hubbard, eds, *The Entrepreneurial City,* (pp. 77–99), West Sussex: Wiley, 1998.

S. Lash and J. Urry, *The End of Organized Capitalism,* Madison: University of Wisconsin Press, 1987.

J. O'Connor, *The Fiscal Crisis of the State,* New York: St. Martins, 1973.

M. Page, *The Creative Destruction of Manhattan, 1900–1940,* Chicago: University of Chicago Press, 1999.

B. Quinone, 'Redevelopment Redefined: Revitalizing the Central City with Resident Control', *University of Michigan Law Review* 27:689–734, 1994.

M. Schill, 'The Impact of the Capital Markets on Real Estate Law and Practice, *John Marshall Law Review* 32:269–312, 1999.

N. Smith, *The New Urban Frontier: Gentrification and the Revanchist City,* New York: Routledge, 1996.

E. Swyngedouw, 'Neither Global nor Local: "Glocalization" and the Politics of Scale', in K. Cox, ed., *Spaces of Globalization* (pp. 137–166), New York: Guilford, 1997.

J. Teaford, *The Rough Road to Renaissance: Urban*

Revitalization in America, 1940–1985, Baltimore: Johns Hopkins Press, 1990.

Urban Land Institute, *New Uses for Obsolete Buildings,* Washington, DC: ULI, 1996.

P. Virilio, *Speed and Politics,* New York: Semiotexte, 1986.

A. von Hoffman, 'A Study in Contradictions: The Origins and Legacy of the Housing Act of 1949', *Housing Policy Debate* 11:299–326, 2000.

B. Warf, 'The Hypermobility of Capital and the Collapse of the Keynesian State', in R. Martin ed.,

Money and the Space Economy (pp 227–240), London: Wiley, 1999.

M. Weber, *Economy and Society,* Berkeley: University of California Press, 1978.

B. Wynne, 'Establishing the Rules of Laws: Constructing Expert Authority', in R. Smith and B. Wynne, eds, *Expert Evidence: Interpreting Science in the Law* (pp 23–55), New York: Routledge, 1989.

S. Zukin, *Loft Living: Culture and Capital in Urban Change,* Baltimore: Johns Hopkins Press, 1982.

Rachel Weber <rachelw@uic.edu> is an Associate Professor in the Urban Planning and Policy Program of the University of Illinois at Chicago. One of her current research projects is an empirical treatment of the issues raised in this article, namely an explanation of why building 'lifespans' have been shrinking in recent years. She is author of the book *Swords into Dow Shares: Governing the Decline of the Military Industrial Complex* (2000)

Image: Residents of Rockwell Gardens, Chicago participate in a clean-up parade, 1969

THAMES GATEWAY SPECIAL

All images in this section, apart from those credited, by John Wollaston, taken between Purfleet and East Tilbury, Thames Gateway, July 2006

DELTA OF HEINOUS: DEVELOPING THE THAMES GATEWAY

INTRODUCTION: ANOTHER GREEN WORLD
by Ben Seymour

Benedict Seymour

Welcome to the Thames Gateway, an 80,000 hectare
development to the east of London on which the
Government has proposed the construction of 'a
city the size of Leeds'. 100,000 new residents, a
wealth of new homes, new megastores, and new call centres on a
wide and flood-prone plain.

After a day at *Mute* researching the proposed mega-devel-
opment, I bump into an old friend on the way home. A keen
bird watcher now training as a biologist, he knows Rainham
Marshes and other nature reserves in the western part of the
Thames Gateway well. We talk about the forthcoming Olympics
(launch pad for the larger Thames Gateway project) and he
assures me that the Lea Valley at least is not going to be turned
into a vast expanse of Bovis housing; the 'water city' proposed for

the area will preserve the canals and the marshes. In short, the Olympics is not necessarily a natural disaster in the making. As a bit of webcrawling reveals, the area is already a complex mix of reclaimed and incorrigible land, a product of centuries of human settlement and industry. Today artificially maintained and nurtured resources offer respite from, or in the case of the Lea Valley, a beautiful discord with industrial decay.

But what about those who live in the mouth of the Thames Gateway, dwellers in the marsh of deindustrialisation and workfare? How is the ecological sustainability sustaining or renewing them? My friend says it used to be unsafe to wander round the marshes, loitering 'chavs' were a menace to the nature-lover. But even this, supposedly, is getting 'better'. Now, he says, potential marauders are mostly engaged in voluntary work schemes, kept busy in that very ecological labour which makes the marshes such a haven for birds and fish and creeping things. Unpaid work as the key to 'urban renewal'? Voles not dole?

The Thames Gateway's propagandists propose the creation of a 'balance' between man and nature, industry and recreation, dwelling and working. The 'healing' of social antagonisms (if not of economic differences), like the harnessing of entropic natural forces, is accomplished through new, 'humanised' forms of exploitation. Putting the 'chavs' to work is analogous to the plans for a détente with the potentially annihilating forces of the tidal river. Learning to accept and to harness the persistence of the working class after their ostensible obsolescence corresponds to the notion of a compromise with the redundant and rising waters of the Thames (maps of the new development incorporate the flood plain into their plans rather than imagining new barriers and defences, water is seen as a source of economic vitality – if properly managed). The surplus waters, surplus humanity and surplus credit flooding the global market are all accepted and granted their place in the new synergies of this former backwater.

In the projected future of the region we see the profit imperatives of the logistics industry happily married to the need for jobs and shopping; as industry is restructured – and older, dirtier industries finally demolished – the threat of social unrest is absorbed by the 24-hour 'flexibility' of service sector work.

As my friend remarks on the taming of the 'chavs', I wince and think of the plans for putting convicts to work, unpaid, on the construction of the Olympic site. [cf. http://www.metamute.org/?q=en/node/7254]. The government are selling this as a tough alternative to prison time. Community NGOs criticize it as over-lenient and a drain on potential jobs for 'legitimate' local workers. But one can see a compromise is possible that would appease both those who position the Olympics as a great 'opportunity' to create jobs for local people and those who see incarcerated proletarians as a cheap labour supply. The utopian renewal of the Gateway seems to involve an acceptance of the permanence of social inequality and of voluntary (or involuntary) servitude.

For capital, the Thames Gateway presents a chance not only to partially resolve the housing crisis in London, as the following articles discuss, but also to reassimilate the ASBOtic excess created by the neoliberal enclosure of London, a meta-stable balance between middle class comfort and safely occupied underclasses. Meanwhile, cutting edge plans for new ecological food and fuel sources rehearse the not so much disavowed as preempted deluge when the Thames floods – or, to invert the hydraulic metaphor, when the housing market and the wider speculative bubble on which all this floats, subsides. So artists such as Nils Norman have leant to the regeneration plans an aura of radicalism and creative re-thinking. His contribution to the 'Thurrock: A Visionary Brief in the Thames Gateway' website [http://www.visionarythurrock.org.uk/] stages a (ironic?) futurological vignette for the repurposing of the defunct Bluewater and Lakeside mega-shopping centres as green algae farms. Norman seems to believe that increasingly popular organic markets could be a mass, rather than an elite, lifestyle option. After shopping centres fall out of favour and global warming jacks up the seas, why not transform the Thames Gateway's consumer dynamos into a source of food? Again, the 'radical' alternatives competing with the expensive but bottom-line driven visions of the Wimpeys and Bovises assume the extension of the credit-and-austerity capitalism of the present some 10, or even 25 years into the future. They build the assumption of scarcity into the putative 'opportunity' offered by the development project just as the government builds in unpaid labour. The idea that further economies must be made seems to be pervasive, an underlying Malthusianism colouring the most 'progressive' projects.

If a lack of historical imagination is implicit in all this (must we all tighten our belts in the name of ecological sustainability? Is it impossible to imagine a mode of social reproduction at once less wasteful and more profligate?), displacement and gentrification are also treated as givens, the background and context of the project. Indeed, as Penny Koutrolikou suggests, the new Thames Gateway may well amount to no more than a suburban solution to the need of the increasingly elite inner-city-population for a convenient, orderly and separate, low wage service workforce.

Are there other, less 'sustainable' and 'constructive' visions on offer? Angry comments in the online forums provided on the Visionary Thurrock site suggest there is plenty of critical thinking about the Thames Gateway going on – at least among those already living in the area. As well as objections to the basic premise that the gateway should succumb to Prescotts' bulldozers and third-rate housing, legitimate enquiries into the subtext of the promise of 'new jobs' that accompanies this, like most other regeneration programmes, are being made. A critic of the future labour relations of Thames Gateway, Dave Amis, has laid out a more likely scenario than Nils Norman's in which Bluewater and Lakeside hang in there, flourishing on continuing (albeit tightening) flows of consumer credit for the time being, to employ, alongside the burgeoning UK logistics industry for which Thames Gateway (in particular, Thurrock) is a key node, an expanding army of flexible and low-paid high-intensity labour. ['Thames Gateway.... Welcome to the Future?' http://www.iwca.info/cutedge/ce0005a.htm]. Rather than assuming increasingly badly paid or unpaid labour as the price of a

'mixed and balanced', 'sustainable' 'community' it might be worth indulging in some alternative blue- (or rather, grey-) sky thinking. For example, given the current state of the UK and global economy, it could be worth considering how many of the financial underpinnings of this project will still be in place come 2012, let alone 2025. As Michael Edwards points out, the Thames Gateway as conceived by the Government and developers will be built on fictitious capital, one more layer in a global pyramid scheme with a great vulnerability to changes in the world market. It is primarily a way of extenuating a bubble rather than, promises of rejuvenated industry aside, the foundations for a new era of productivity. If renewal means shit work and Olympic 'chain gangs', what would a dysfunctioning industrial renaissance look like? Do we really want to present more 'progressive' versions of the Thames Gateway or should we not be talking to those on the receiving end of middle class reveries about resisting this latest regeneration onslaught? If there is a recession and restructuring of the economy it will be predicated on shifting the crisis onto the poor to an even greater degree.

One thing's for sure, as long as unpaid labour is part of the 'visionary' plans for a new city, the Thames Gateway project stinks worse than marsh gas.

Benedict Seymour <ben@metamute.org> is deputy editor of *Mute*

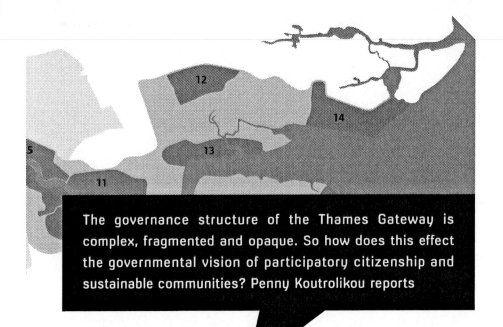

The governance structure of the Thames Gateway is complex, fragmented and opaque. So how does this effect the governmental vision of participatory citizenship and sustainable communities? Penny Koutrolikou reports

GREAT EXPECTATIONS: GOVERNING THAMES GATEWAY by Penny Koutrolikou

The heart of the Government's election manifesto earlier this year was a commitment to build a country 'more equal in its opportunities, more secure in its communities, more confident in its future'. The Gateway provides both a symbol and a test case for that commitment.

– David Milliband, November 2005 (Minister of Communities and Local Governance 2005-06)

Despite repeated assertions of commitment to 'good urban governance' and 'sustainable communities' from those involved, the overall structure of the Thames Gateway project remains largely unclear. This raises serious questions about the rationale behind it and the way it will be implemented.[1] Like other regeneration projects, the very opacity of the process is, in practice, likely to render the rhetoric of local democracy hollow.

Thames Gateway is one of the largest – if not the largest – development projects in Europe. Apart from its size and development potential, its real importance lies in the great expectations attached to it – principally that it will resolve London's ever-growing need for housing in a way that does not upset the already high property values of inner London. By displacing the problem to the poorer East via urban sprawl, strategists aim to develop new residential areas that could provide a large percentage of the 'affordable' housing currently lacking within the city. Additional arguments about economic development and maintaining competitiveness in the light of emerging global centres such as Shanghai are presented as further incentives to the city's eastward growth.

The question that goes unasked in all the talk about sustainability is how the new 'sustainable communities' intended to take advantage of this housing can develop if the new city has no infra-

Thames Gateway Zones of Change

 1 Isle of Dogs
 2 Deptford and Lewisham
 3 Greenwich Peninsula
 4 Stratford, Lower Lea, Royal Docks
 5 London Riverside and Barking
 6 Woolwich, Thamesmead, Erith
 7 Kent Thameside
 8 Medway
 9 Grain
10 Sittingbourne, Sheerness
11 Thurrock Riverside
12 Basildon
13 Canvey, Shellhaven
14 Southend

Image: GLA London Thames Gateway, Development
and Investment Framework,
http://www.london.gov.uk/mayor/planning/docs/tham
es_gateway.pdf

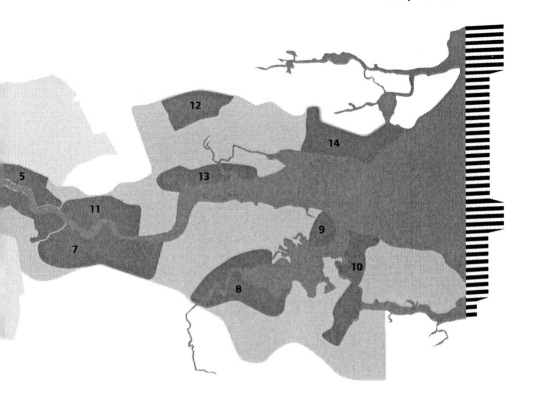

structure and no local facilities to support it. What kind of residential areas will these be if, as seems likely, they are developed as atomised islands in the 'uncharted waters' of Thames Gateway?

Structural Adjustments

In such a large regeneration scheme, or more explicitly, in the construction and management of a city within a city, governance issues are indeed decisive. In the case of Thames Gateway there are several ques-

tions to be answered: first, how do the current governance structures communicate with the area's residents and with other organisational structures; second, what are the governance structures that will oversee the delivery of the new projects; and third, how will these structures relate to the future communities of Thames Gateway?

Despite government commitments to 'community involvement', Thames Gateway is still primarily a central government led project. The strategic advisory group, Thames Gateway Strategic Board, consists of high-up government officials

and ministers who put forward their different agendas and aims, negotiate about how they can be achieved, and provide the overall 'strategic vision' for the area. So far this approach has almost crippled the project since the private sector has failed to come up with the anticipated investments needed to push Thames Gateway forward. As a result, it seems plausible that future developers and investors will be offered further incentives – or even 'carte blanche' – in return for participating in the development of the region.

part of the putative Thames Gateway community (new or old) will hardly be fostered by all this.

Trying to unravel the riddle that is governance, we encounter a broad range of partnership-based organisations reflecting the complexity and scale of the project. Besides the strategic group, the only body with an overall view is English Partnerships, but they mainly focus on development facilitation and land remediation. Other key players in the governance structure are the three Regional

the new developments could end up primarily a dumping ground for those forced out of London

The 2012 Olympics provide a further means by which to secure support for the development – both public and private. Indeed, geographically and economically, the Olympics represents the gateway to the Gateway.

If the governance structure for the 'delivery' of Thames Gateway is a defining factor for its future, the structures of this governance remain far from clear and so far there is limited public information on how it is supposed to operate. Similarly, the roles and responsibilities of the bodies involved are blurred in the overall complexity. Meaningful involvement in decision making and resource allocation on the

Development Agencies (London, East of England and South East). Then there are the 'delivery organisations' in the Thames Gateway charged with turning the 'vision' into reality: London Thames Gateway Development Corporation, Greenwich Partnership; Bexley Partnership; Thurrock Thames Gateway Development Corporation; Basildon Renaissance Partnership; Renaissance Southend; Kent Thameside Delivery Board; Medway Renaissance Partnership; and Swale Renaissance. These organisations represent both the delivery vehicles for development and, in some cases, local governance initiatives in the form of local partnerships. As a recent academic report puts it:

Although Thames Gateway is promoted by central government as a coherent geographical entity united by a single strategic vision, in reality there are at least three distinct areas: London, Kent and Essex, each with its own management structure and set of public-private partnerships. As one member of the Thames Gateway board told us: 'Basically what you have [in the Thames Gateway] are three separate areas, and things are different in all of them. In Kent you have the County Council and one developer for the whole area, but in Essex the County [Council] is working with three, four different [development] partners.' **2**

Additional organisations that have more of a lobbying and local governance remit include the Thames Gateway London Partnership, Kent Partnership and Essex Partnership whose boards are mainly made up of Local Authority officials and Councillors and other 'important' players such as major local developers.

Politicians and central government continue to reiterate that sustainable development and thriving communities depend on active community involvement. Yet the bottom-up 'community participation' component acting to influence and direct all these top-down structures seems to rely primarily on the London Thames Gateway Forum [http://www.ltgf.co.uk], the community and voluntary sector representatives that sit in the Local Authority Strategic Partnerships, and local campaigns. Already it seems that community involvement is going to be achieved primarily through community consultations over proposed developments and negotiations regarding the allocation of the relevant 'planning gain'. In planning jargon this denotes the 'community compensation' that developers give in support of local facilities. Planning gain may include 'affordable' or special needs housing, provision of education facilities or open space, infrastructure for business, sustainable transport to meet the need created by the development, etc.

However, in these crucial negotiations over the location and extent of resources the developers and the Local Authority are the key players, with local groups primarily taking an advisory (or, at best, campaigning) role.

Gated or Ghetto Gateway?

Adrift in this sea of organisations and partnerships one starts to wonder about their actual functions, responsibilities and powers, their potential overlap and duplication, lack of transparency and, therefore, of accountability. This 'problem' has of course been acknowledged by politicians and academics alike, but in the end the fundamentals of governance mitigate against 'solving' it. As the paper quoted above describes, the coordination of the various organisations remains in the hands of the state:

Although a limited degree of co-ordination for the whole of the Thames Gateway area has been provided by a joint operating committee including the chairmen and chief executives of the three RDAs (Regional Development Agencies) involved (…) and representatives from the three area management boards, real strategic oversight is provided directly from central government.[3]

If the key structures providing oversight for the development are dominated by government officials and interest-led members (such as representatives of property consortiums like Land Securities), to what extent are issues of sustainability, build quality and local provision up for discussion? Private support is too essential to jeopardise.

Given the housing targets set for Thames Gateway, the project will most likely be delivered through the development of large plots of land by consortiums of developers. This is likely to result in self-contained residential developments. In negotiations over planning gain Local Authorities tend to recognise the need to balance developers' profits against the need for local infrastructure and service delivery. However, since this process of 'balancing' takes place behind closed doors and under pressure from central government to push these developments forward, it is likely to be seriously biased in the developers' favour.

Rather than checking their excesses, the 'distributed' power structure of the Thames Gateway development seems likely to assist developers in the continuation of the 'state of emergency' announced by the 2012 Olympics. In line with central Government policy,

power is displaced from the planning departments of the Local Authorities to the Urban Development Corporations (such as the Thames Gateway UDC) in order to deal with the 'emergency' of achieving development results. All this favours the scenario of a Thames Gateway of fragmented, car dependent enclaves that turn their their backs on existing (and less affluent) local centres and communities while consuming their facilities. If the Institute of Public Policy Research's recent report 'Gateway People' (2006) can be relied on, the middle class are not going to be early adopters of the Thames Gateway brand - Essex just isn't sexy enough in 'culture and heritage' terms. Instead, the new developments could end up predominantly a dumping ground for those forced out of London. But the middle class residents who do come will likely concentrate in a series of insular enclaves, producing a fragmented urban collage reminiscent of the complex, opaque and fragmented structure of the Thames Gateway's governance. Not sustainable 'urban villages' but gated Gateway communities amid Gateway ghettoes.

Any prospect (or threat) of the democratic and community led 'civic Gateway' hailed by New Labour- replete with participatory design, participatory budgets, citizens' juries, neighbourhood charters and possibly community managed assets - is effectively buried under the dense meshwork of developer-dominated governance. ⍨

Footnotes

1
For example, the EU Ministerial Informal on Sustainable Communities in Europe (Bristol Accord, 2005) and John Prescott's 'sustainable communities' agenda for the UK.

2
'The South East Region', by P. John, A. Tickell and S. Musson, in *England The State of the Regions*, J. Tomany and J. Mawson (eds.), Bristol: The Policy Press, 2002.

3
Ibid.

Penny Koutrolikou
<p.koutrolikou@bbk.ac.uk> is a lecturer in regeneration and community development at Birkbeck College, and she is currently working on the effects of local development and governance on inter-group relations

The Thames Gateway looks set to be the latest in a long line of 'great' British planning triumphs including Milton Keynes and London's Docklands. But is it possible it could be worse than either of these?

Michael Edwards is a professor of planning at the Bartlett in London. Here he analyses the likely outcome of the Thames Gateway project, and offers his own alternative vision for redevelopment

BLUE SKY OVER BLUEWATER by Michael Edwards

The Thames Gateway project poses daunting choices for those with the power to decide on the future development of South East England. Government and the Mayor of London both agree that most of the region's growth should be concentrated in the Thames estuary. They share the assumption that London has to expand East, not West, and that the supposed rationality of capitalist growth is the only telos in (or out of) town.

But is this even a good project on its own profit-driven terms? A toxic mix of de-regulation, state subservience to corporate interests, political cowardice and collective amnesia about how to do urbanisation, all the signs are that Thames Gateway will be UK regeneration plc's biggest debacle so far.

It doesn't have to be this way. The new city could be a laboratory for innovation in ways of living, ways of building and ecological relationships. The reality may be somewhere in between. In this article I will sketch my worst and best case scenarios. First, a bit of background.

Capital Problems

London is a problem region and its eastern part has special problems. London sucks in wealth created around the world, staffs its hospitals and services with people trained in poorer countries and drains the skilled people from much of the UK.[1] Meanwhile its internal unemployed 'surplus population' (of many ethnic groups including poor whites) remain largely overlooked within the city, squeezed between low wages or benefits and high living costs.

One result of this sucking in of resources and of highly educated people is economic growth, hailed as 'wealth creation'. The growth package comes with expanding employment and population and even faster price increases, especially for housing. The government and the Mayor of London just welcome all this expansion and insist that London somehow has to go on growing. We are told that any restriction of this growth could kill the goose that lays the golden egg: investors would go elsewhere.

Expansion along the radial corridors to north, south and west could be a good solution but there is a taboo on that because of the strength of resistance from the property-owning

classes who defend themselves so vigorously in the green belt round London. The county of Buckinghamshire fought off the threat of urbanisation in the 1960s by telling the government that, in return for preserving the leafy Chiltern Hills, they could have a free hand around the stinking brick kilns (and Labour voters) of Bletchley. That's how we got Milton Keynes. Now we get the Thames Gateway for much the same reasons: the people east of London could do with more jobs and the NIMBY forces simply are less powerful out that way.

London has a long history of problems to the east. This is where the most polluting industries went, outside the environmental and safety controls of the old London County Council – east of the River Lea on the north bank and east of Greenwich on the south bank. It was the backyard of London with power generation, garbage disposal as landfill in the Mucking marshes, car-breaking and the rest. It also had the Ford plant at Dagenham, oil refineries, cement, armaments, paper and cardboard manufacture among its main industries. With the destruction of manufacturing in the UK since the Thatcher period this part of England suffered catastrophic job losses which produced an abandoned working

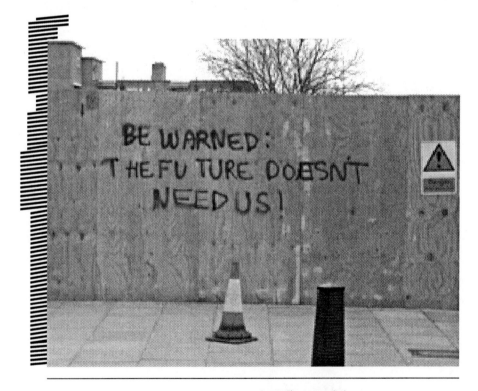

Image: Slogan on a site in Hackney: a workshop demolished to make way for luxury housing. Photo Michael Edwards 2005

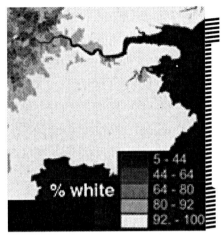

% white

5 - 44
44 - 64
64 - 80
80 - 92
92 - 100

Image: Racial Mapping of TG, http://www.bartlett.ucl.ac.uk/planning/images/Fig1white.tif

class and a fertile ground for racism.

A bit away from the rivers, the east has long been a dormitory area to which east Londoners have moved when they could afford to do so, and these movements have been disproportionately of white people. London itself may (and should – see *Mute* vol 2, no. 2) celebrate its diversity but at the edges of Greater London and especially in the counties beyond its boundaries the social landscape is very white.

Employment growth has been strongest in central and western London. That trend follows the market, reinforced by decisions to expand Heathrow and by Ken Livingstone's determination to foster finance and business services in the centre. London cannot house its growing labour force so it has to suck more commuters in from outside – especially from the dormitory areas of the east which are the least self-contained parts of southern England. From the point of view of employers in the City, West End and Docklands, their future growth depends on even more commuting from Kent and Essex. But the trains which bring them in are jam packed and central London employers (and property owners) are pushing for investment to increase their commuter capacity. Services from Kent will start running on the Channel Tunnel Rail Link tracks in 2007 and there is strong pressure for that to be followed by 'Crossrail', although the wider economic and social justifications for it are weak.

Ken Livingstone now has some influence over the privatised suburban railway system of the region, but Transport for London (TfL) is struggling to find ways to enlarge the system's capacity to get the new workers in to the centre, even with massive state investment and maintaining a 2006 level of overcrowding on the trains. And it is very wasteful: every packed train coming in to the centre runs back nearly empty for the next load of Kent and Essex commuters. This is less of a problem going out of London in other directions to places such as Milton

Keynes, Watford, Reading and Gatwick. There are more jobs out there and thus more reverse commuting. Major population growth in the east thus has disadvantages from an energy point of view.

Another problematic feature of this eastern region is ecological. The modern parish of Mucking, for example, has been described as one of the most derelict on the north shore of the Thames (Astor 1979): the higher land worked for sand and gravel, and the marshes along the river covered by London rubbish (Middleton 1994). The Thames Gateway needs a major investment to clean-up polluted land; the huge landfilled marshes at Mucking may be damaged beyond repair and many of the areas proposed for urban development are vulnerable to flooding – either now or as a quite likely result of global warming in the future.

Worst case scenario...

If the Thames Gateway project goes ahead with some of these major challenges unresolved, pessimistic foresight suggests the following:

The cost of making it happen at all – building transport and social infrastructure as well as subsidies for clean-up of land – is an endless drain on state investment. The 2012 Olympic and Paralympic Games helps a bit in this respect because the sheer imperative of being ready on time for the Games permits normal decision-making and consultation to be compressed and ensures that budgets will be found to do roadworks and other bits of infrastructure in the national interest. Even that is not enough, however, and much of the infrastructure lags years behind the need.

The growth of the region's population and income in turn boosts growth of property values in the south of England, leaving the west and north of Britain to struggle. Government statements about regional policy – already very feeble – become even less convincing as state expenditure on the Olympics, and then on urban infrastructure and housing, further overheats the South East. As house prices (and rents) are driven up in this way, low- and middle-income people suffer worsening housing conditions, more overcrowding and dependence on housing benefits.

Mass private housebuilding firms are cajoled into building thousands of houses a year but each development serves just a single market segment and income group. The higher ground and fine landscapes get the 'executive' homes; the marshes and degraded areas get denser blocks of apartments, euphemistically called 'starter homes', and 'affordable' housing. The housebuilding industry remains profitable, though this is largely because selling prices are growing year after year: housing in Britain remains poor value for money in European terms and more than half of what you pay for a dwelling is payment for the scarcity of land, not for the dwelling. A steady influx of workers from eastern Europe cushions the construction sector from the need to modernise itself.

Apart from jobs in construction, the economy of the Thames Gateway grows

only slowly, so its population remains dependent on long-distance commuting, mainly to Central London. There are more trains running, but they still have cattle truck conditions. Stratford, Ebbsfleet (a.k.a. Bluewater) and Ashford have high speed, and expensive, services to St. Pancras but many areas are only served, at best, by ludicrous extensions of the Docklands Light Railway – in truth just a tram –with dozens of stops between home and work. Anyone who has sat for an hour on the Athens tramway to the southern suburbs (built for the Olympics) will know what I mean.

Some prestige architecture will decorate this messy picture, with flagship projects here and there. There are wonderful designs by Zaha Hadid, AHMM, Bernard Tschumi and Colin Fournier... But these are fragments lost in a sea of mediocrity, dominated by routine architectural firms commissioned by big development companies and the 'Registered Social Landlords' who have already shown that they often do no better.

A lot of money is made even in a low-grade development of Thames Gateway. Pressure of demand for space in London is so strong that everything sells sooner or later and property values grow through the agglomeration of activity and the new infrastructure. But the profits from this are all private because successive governments have not had the nerve to hold any long-term land ownerships or equity shares. Governments insist on getting 'planning gain' contributions out of private developers for social housing, infrastructure and so on. But they do it in year one, just when the developers can least afford to pay and long before the trees have grown and the serious land values built up. In this worst case scenario it is always the state and public bodies that come to the rescue, firefighting on service provision, patching infrastructure. There may be some exemplary water-management and local-energy schemes – these are being promoted hard just now by the Deputy Mayor and likely to figure strongly in the next London Plan. But these schemes need continuing management to work and if all the profits have been given away – either to initial developers or to individual owner-occupiers – these costs will be hard to cover.

The British appear to have forgotten the positive aspects of the 20th century new towns programme. One of the great strengths of that programme was that it was financially sustain-

able in the medium and long term. Large-scale urban development involves heavy initial costs while the benefits are reflected only very slowly in rents and property values as each city matures. In the new towns of Britain the government agencies which built them retained ownership of a lot of the land and buildings and could thus recoup the investment

and pay off the loans. This is just what we are failing to do in the Thames Gateway: as with Mrs Thatcher's Docklands project in the '80s, all the valuable assets end up in private hands and there is no flow of public or collective funds to pay for maintenance or services or repay the debts incurred in the initial infrastructure. [Editor's note: An early Thames Gateway plan was drafted by Michael Heseltine during John Major's government.]

And the best case...

Instead of wallowing in amnesia, Britain's professions and politicians do a bit of remembering what their predecessors

were good at, a bit of learning from foreigners and a lot of innovation. This is a more optimistic view from about 2025.

Thames Gateway develops, but more slowly than in government plans of 2006. This is partly because major elements of

Some prestige architecture will decorate this messy picture

government and cultural institutions have been spread to other regions, partly because other development corridors are evolving: through Watford, Berkhamstead and Tring to Milton Keynes and Luton; through Surrey and Sussex to Gatwick and through east Hertfordshire to Stansted and Cambridge. London's old 'green belt' plan is being replaced with something more like the 'finger' plans of Copenhagen and Stockholm. Almost all those living in the new areas can leave home and walk one way to a good shopping centre and railway station, the other way to green space and allotments, stables or golf course. The choice between urban and rural situations is over: most people can have both, not just those in Hampstead, Richmond or Stanmore.

Within these new 'fingers' all the land has been taken in to the ownership of Land Development Trusts. They are very diverse but what they have in common is that they retain all the freeholds and grant building leases subject to ground rents which are annually revised in line with market conditions. This means that these collectivities gather about half of the growth in property values while the owner-occupiers or other users of land get the other half. It's a fair exchange because this revenue covers all the costs of infrastructure and services, maintenance of ecological systems and community services. It is a good long-term investment and is financed with bonds which have proved very successful in an increasingly volatile world financial system. These have been investments in real things (infrastructure and service spaces) which actual people use and pay for so they are more robust than the highly speculative investments which the geographer David Harvey called 'fictitious capital' – investments made in the hope of capturing some imagined future profit.[2]

From about the year 2000, many countries – led by the USA – created a new kind of tax-exempt investment company for holding real estate – 'Real Estate Investment Trusts' (REITs) there and with other names elsewhere. These brought a lot of new money into property investment, mainly in shopping centres, offices and so on. But from about 2005, these funds began moving into the large-scale ownership of housing on the assumption that money could be made by speculative selling or by jacking up the rents being paid by tenants. In Germany many hard-pressed

municipalities and social housing organisations sold thousands of (occupied, tenanted) dwellings to these investors, causing severe alarm. Following the rent strike against Real Estate Investment Trusts across the whole of Germany in 2008, international investors have switched from asset-stripping social housing to safer investments like this.

The bond-financed equity-sharing system used in the London region from 2007 is a modified version of the site lease-hold system which gave us Bloomsbury in the 18th and 19th centuries and many other high-quality urban areas in Britain. In those early cases it was a private owner who held the freehold and thus got the

long-term benefits – indeed it was mostly aristocrats. But the system works as well or better when the long-term owner of the collective rights is a public or collective body with no outside shareholders. It is similar to the Hong Kong system which produced half the income needed by the colonial administration, enabling tax to be kept very low. And it draws on the lessons from Britain's post-war new towns which Margaret Thatcher privatised just when the profits were really rolling in.

Another great innovation in the Thames Gateway has been in the configuration of street systems and shopping/service centres.[3] No longer do we have hierarchies of main and 'distributor' roads, with

shops and services in isolated islands away from passing trade. Instead the frontages to main urban roads are all lined with shops, schools, offices and other services, with parallel service roads for cycles, buses, trams and cars. Passers-by can (and do) stop for services and everyone has shops within 10 minutes walk and a B+Q within 10 minutes drive. There is so much of this commercial space that rents for it are rather low and the new development areas have become a breeding ground for new business: only here can shopkeepers combine local customers, online customers and the regional customers who come and hunt them out. There are no double red lines here.

The London Plan has put a lid on further office development in and around the centre of London, just as Paris did to ensure that its suburban employment centres took off at La Défense and at Marne-la-Vallée. These two huge developments were not much use, however, to the impoverished residents of the working-class suburbs of Paris who have been widely excluded from the general economy – but they did show what could be done to make a region more poly-centric.

The British real estate fraternity were furious initially but now find there are plenty of good investments in these prospering London suburban nodes, and they are much less volatile than central London, which was all they knew about until about 2010. Communities living round King's Cross, the Elephant and Castle and London Bridge breathed a sigh of relief and got on with life, the threat of displacement much reduced.

Because employment growth in Central London has slowed, more jobs are being created out in the suburban nodes. There is quite a bit of reverse (outwards) commuting so the trains are used in both directions. The massive investment in Crossrail was not needed and has been re-directed into a better network mesh of routes linking suburbs, using a mix of trains, trams and buses.

But probably the biggest transformation has been in housing. Barratt, Persimmon and their like, whose main skill was managing their land banks and timing their developments, have re-directed most of their work to Dubai and Shanghai. In their place we have a whole new industry based on cheap and plentiful land supply. Users of land pay over the long run through their ground rents (see above) instead of up-front. A consortium of Stuart Lipton, Ikea

The imperative of being ready on time for the Olympic Games permits normal decision-making and consultation to be compressed

and John Lewis dominates the production of modular building components so that building enterprises get economies of mass production whether they are big or small. It is the modernist dream come true but with a thoroughly post-modern outcome: every dwelling can be different. Whereas new housing used mainly to be aimed at first-time buyers and new households, current output targets a huge range of market segments – often in the same development. So thousands of elderly Londoners have moved out of their big houses and flats where they could afford neither the maintenance nor the Council Tax and now live in the Thames Gateway. The key attraction for many of them was dwellings with few but spacious rooms, bookable guest rooms for visiting friends and families nearby, plenty of children and younger people around (but out of earshot) and an easy transition to more supported form of living as they get more decrepit. The housing associations, co-ops and developers which understood this, and the architects who helped them, have become immensely successful.

Part of the buzz in the Thames Gateway comes from this shift away from totally individualised housing, highly popular with people in all age groups including young workers. The growth of co-housing and of various forms of cooperatives has produced both a revived sociability and a major reduction in the environmental impact of falling household size.[4]

Another distinctive feature of development in the Gateway is the wide range of densities of building, ranging from 20 to over 1000 habitable rooms per hectare. All the developments have to meet a zero carbon emissions standard and all the low density developments have to make big net energy contributions to the local or national grid to compensate for the fact that their residents

are bound to drive a lot more. A good example of the results is at Mucking in Essex where the high river terraces (with long views across and down the estuary) were intensely settled by Romans and Anglo Saxons in the first millennium. They were then removed by gravel quarrying in the 1970s and are now re-settled as a busy town, mostly below-ground, but with balconies, terraces and gardens on all the space not covered with photo-voltaic panels.

Conclusions

Thames Gateway is neither bound to succeed nor bound to fail. But it will be hard to make into a great success. It is not the kind of development which the property market, left to itself, would undertake. But government is determined to impose it on a reluctant market, aided by its success in securing the Olympics for 2012: the Games helps to keep the speculative housing bubble inflated and provides patriotic legitimation for state expenditure. ⑂

Bibliography

M. D. Astor, 'The hedges and woods of Mucking, Essex', J. Panorama, Thurrock Local History Society, 22, 59-66, 1979.

T. Butler and M. Rustin (eds), *Rising in the East: the regeneration of East London*, London 1996.

M. Gordon, 'Thames Gateway: sustainable development or more of the same?', *Town and Country Planning*, 63(12), 332-333.1994.

Mayor of London, *The London Plan: the Spatial Development Strategy*, London 2004.

C. Middleton, 'The road to Mucking: How does a banana skin in a bin end up in Essex?,' *Evening Standard*, 25 Nov, 1994, p. 10-12.

Footnotes

1

A. Amin, D. Massey and N. Thrift, *Decentering the Nation: A Radical Approach to Regional Inequality*, Catalyst, London, 2003. Doreen Massey, to follow, in *Soundings*, summer 2006.

2

D. Harvey, *The Limits to Capital*, Oxford, Blackwell, 1982.

3

On this see M. Edwards, 'City design: what went wrong at Milton Keynes?', *Journal of Urban Design* 6 (1): 73-82, 2001, http://linkme2.net/9i

S. Marshall, *Streets and Patterns*, London, 2004, Spon; Space Syntax http://www.bartlett.ucl.ac.uk/research/space/overview. htm

4

See J. Williams, 'Innovative solutions for averting a potential resource crisis — the case of one-person households in England and Wales' *Environment, Development and Sustainability* 8(3): 1 – 30, 2006.

Michael Edwards <m.edwards@ucl.ac.uk> is a specialist in property markets and planning at the Bartlett School, UCL, in London www.bartlett.ucl.ac.uk/planning He is active in the London Social Forum on London planning issues. Blog at http://www.michaeledwards.org.uk

SUBSCRIBE TO MUTE!
Subscribe now and get *Mute* Vol.2 at the discount price of £18 a year. Further discounts on two and four year subscriptions. See over for more details.

CALL OUR CREDIT CARD HOTLINE ON 020 7377 6949
Subscriptions will start with the current issue, unless otherwise specified.

GIFT SUBSCRIPTIONS:
If you are giving *Mute* to a friend, you can leave their details on completion of your purchase together with your own payment details. Your friend receives a special gift card together with the first issue of the magazine; our gift to you is a back issue of your choice.

INSTITUTIONAL OPTIONS:
T: +44(0)20 7377 6949
F: +44(0)20 7377 9520
E: subs@metamute.org

ADDRESS CHANGE:
If you are an existing subscriber needing to change your address, then please email us on subs@metamute.org

go to www.metamute.org/product

subscribe

Subscription Rates:

	individual		institutional/company	
	4 issues (1 year)	8 issues (2 years)	4 issues (1 year)	8 issues (2 years)
uk	☐ £18	☐ £34	☐ £27	☐ £51
eu	☐ €25	☐ €48	☐ €38	☐ €71
usa/can/mx	☐ $22	☐ $41	☐ $32	☐ $61
other	☐ €29	☐ €54	☐ €43	☐ €82

Please tick the appropriate box.

I wish to pay by cheque/credit card.

☐ I enclose a cheque (GBP) made payable to Mute.

☐ Please charge my

☐ Visa ☐ Access ☐ Mastercard ☐ Switch

Card no. ☐☐ ☐☐ ☐☐ ☐☐ ☐☐

Expiry date ☐☐ / ☐☐ Start date ☐☐ ☐☐

[Switch only] Issue number ☐☐

Signature _____

name _____

address _____

town/city _____

post code _____

country _____

POST TO:
MUTE, Unit 9, The Whitechapel Centre
85 Myrdle St., London E1 1HL UK

Or call our credit card hotline 020 7377 6949,
Fax 020 7377 9520

Web http://www.metamute.org/product
Email mute@metamute.org

Printed in the United Kingdom
by Lightning Source UK Ltd.
114490UKS00001B/94-183